Harald Mante

Serial Photography

Using Themed Images to Improve Your Photographic Skills

With Eva Witter-Mante

Harald Mante (www.harald-mante.de)

Editor: Gerhard Rossbach
Translation: Jeremy Cloot
Copyeditor: Cynthia Anderson
Layout and Type: Harald Mante, Birgit Bäuerlein
Cover Design: Helmut Kraus, www.exclam.de
Printer: Golden Cup
Printed in China

ISBN 978-1-933952-73-4

1st Edition 2011
© 2011 by Harald Mante

Rocky Nook Inc.
26 West Mission Street Ste 3
Santa Barbara, CA 93101

www.rockynook.com

Library of Congress Cataloging-in-Publication Data

Mante, Harald.
 [Fotoserie. English]
 Serial photography : using themed images to improve your photographic skills / Harald Mante.
 p. cm.
 Translation of: Die Fotoserie. Heidelberg, Germany : Dpunkt Verlag, 2010.
 ISBN 978-1-933952-73-4 (soft cover : alk. paper)
 1. Photography--Technique. 2. Photography, Artistic. 3. Mante, Harald. I. Title.
 TR179.M35513 2011
 771--dc22
 2010034565

Distributed by O'Reilly Media
1005 Gravenstein Highway North
Sebastopol, CA 95472

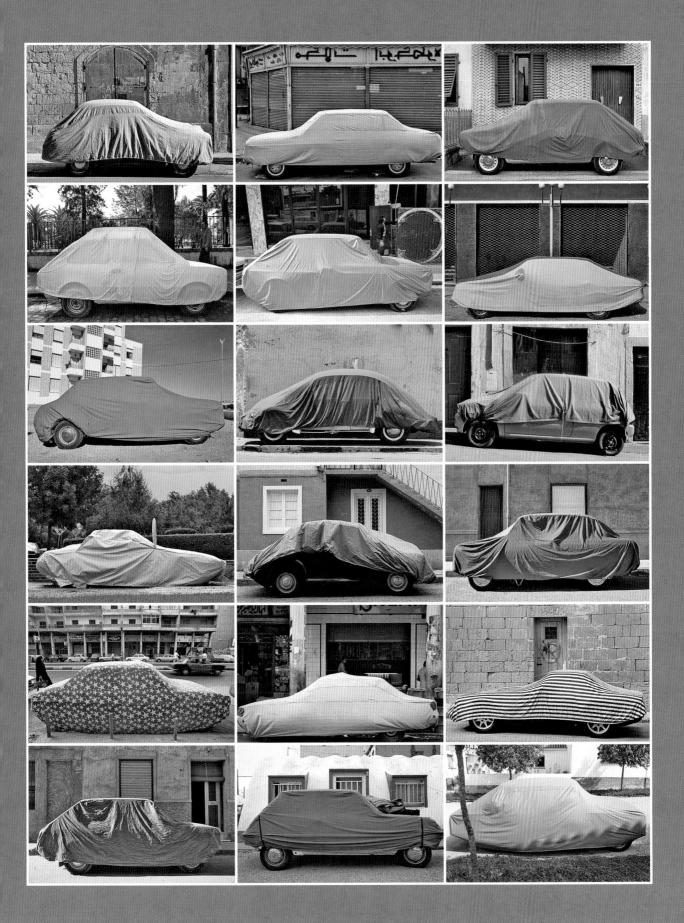

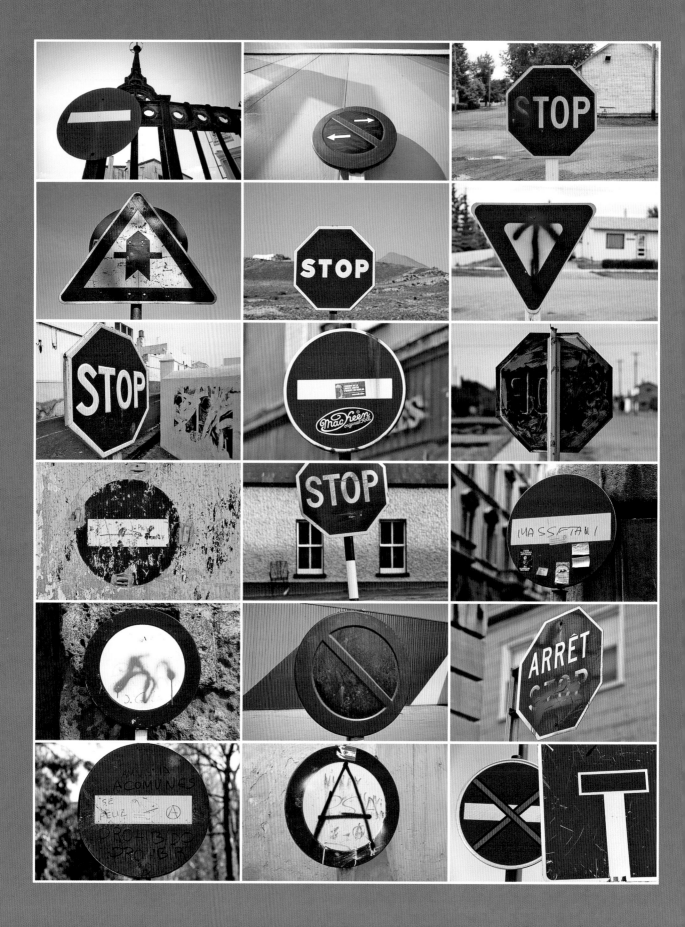

Table of Contents

Part 1 Serial Photography General Themes 1

Part 2 Serial Photography and Design Theory 83

Part 3 Serial Photography and Color Theory 105

Part 4 Serial Photography Special Themes 127

Part 1

Serial Photography General Themes

If you consider the photographic medium in general, you will probably end up thinking about individual artists or even specific, individual images—moments that changed history or simply images that left a lasting impression. The desire to produce this type of image yourself is a lofty ambition. A simple but effective alternative to the endless search for "the" defining, prize-winning image is to take a series of photos that deal either with single or multiple themes, and in which each image has its own formal qualities.

In additional to thematic collections, photographing images in series can also help to depict time and space. Here, it is important to understand the difference between a "series" and a "sequence." A sequence either has its own overriding theme or serves to visually explain an accompanying text. Additionally, sequences are usually shot in a single session, although long-term sequences do exist, too. The photos in a sequence are usually presented in a uniform size and in strict order. Serial photography allows the photographer much more creative freedom. Many of the formal elements of a sequence are not required in order to create a successful series.

Some of the basic "rules" of serial photography are:

▶ You can shoot whenever and wherever you like
▶ You can shoot in portrait or landscape format
▶ You can always discard old images, or extend and augment a series with new material
▶ Serial photos can be presented in many different ways

Once you have developed a taste for serial photography, you will notice that some images are suitable for use in a number of different series. For example, the first image in the *Umbrellas* series could just as well find a place in the *Triples*, *Automative Reflections*, or even the *Blue* series. There is hardly any subject that cannot be developed into its own series—for example, photojournalists are extremely well placed to create a series about handshakes at every level of society. Multiple images with a common theme challenge the viewer to take a closer, more comparative look at the subject matter. A photo series encourages you to look for similarities and differences between everyday objects, and the mental sorting involved nearly always leads to the creation of additional subthemes and alternative series. It is easy to imagine developing the *Manhole Covers* idea to make a series that includes just circular or square covers.

1 Houses

The Perfect Subject for a Travel Series

Villages, towns, and cities owe their individual appearance to the buildings in them. At some point in history, early huts and houses shed their purely functional role and began to visually symbolize status and wealth. The differences between them can take the form of formal architectural details or the simple use of different colors and patterns on walls and roofs.

In most cases, the cost factor dictates that residential buildings are built using simple square units topped off with a triangular roof gable. Free-standing houses can gen-

erally be photographed in landscape format, but need space at the sides and above to make a real impression in a photo. Space that you leave around a subject acts as a "negative form" that emphasizes the "positive form" of the subject itself. If circumstances allow, it is preferable to photograph houses so that the vertical and horizontal alignment of the building's lines is mirrored in the finished photo. The vanishing point of such single-point perspective images is behind the subject in the center of the frame. If you are photographing larger buildings or if space is limited, you

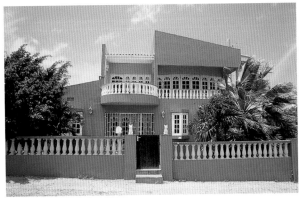

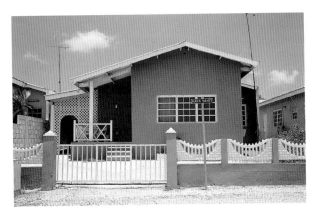

will often have to tip your camera upward to capture the entire building, creating dynamic-looking images in which the vanishing point lies beyond the upper edge of the frame.

Most vertical lines in architectural photos converge. Initially, following the introduction of the first wide-angle lenses, converging lines in architectural photos were frowned upon. However, the famous Bauhaus exhibition of "New Photography" in Stuttgart, Germany in 1929 changed all that, and free use of the camera—including deliberate

use of converging lines—began to be accepted as an integral aspect of modern image composition. If necessary, modern image processing software makes it child's play to eliminate converging lines.

A photographer should always consider how the compositional elements—point, line, shape, and artistic contrast—are used in an image. In the case of our *Houses* theme, the architectural façade forms a shape within a shape. Details such as windows, doors, and roof angles create tension of their own within the house element of the

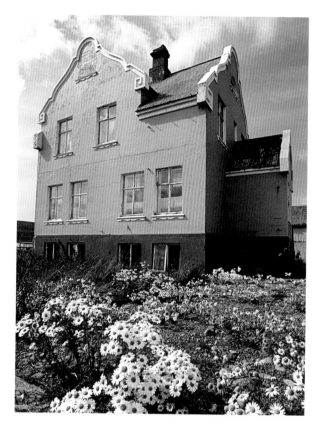

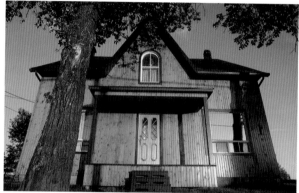

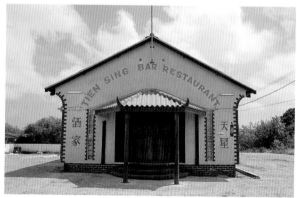

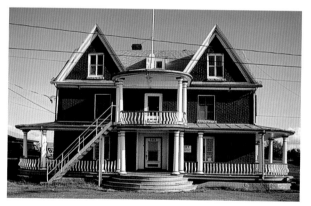

image. The photographer can only influence the interplay between the building and its surroundings, perhaps by using an extreme viewpoint or the effects of changes in the ambient light.

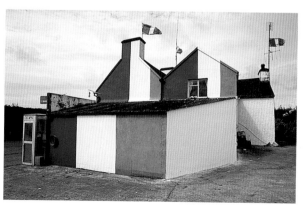

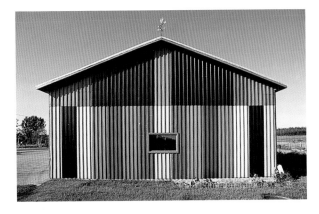

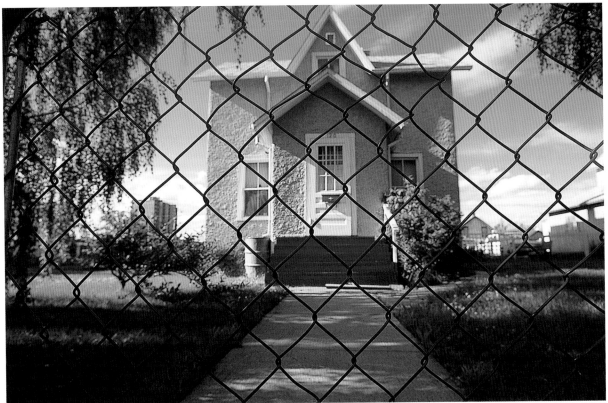

About the Photos

Houses are an obvious subject for photographers who travel. You will always pay more attention to new surroundings than you do to familiar places. In #1 and #8, I deliberately used converging lines caused by unavoidable proximity to the subject as part of my composition. In contrast, photos #2, 3, 4, 7, 9, and 11 were all shot frontally, creating a static feel, while the buildings in #6 and #10 have a more dynamic feel, thanks to a camera angle that makes a corner of the building the center of the viewer's attention. In #5 and #12, the buildings are part of a multi-dimensional composition and play second fiddle to the effects produced by the trees and the fence.

2 Stairs

Moving Up and Down

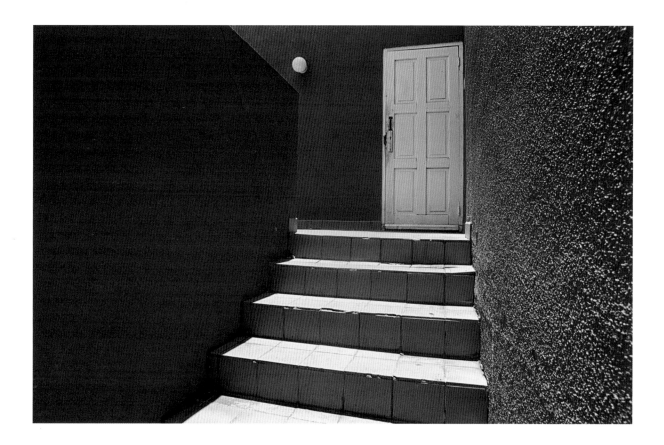

Stairs are an important and ubiquitous design element in public and private buildings, and serve to help negotiate differences in elevation in both upward and downward directions. Photos of stairs are largely defined by line elements in the form of primary horizontals and verticals, or rising and falling diagonals. The differences between the thickness of lines and the occurrence of stripes (the thickest of all lines) are a matter of subjective taste, and are underscored by the variety of designs and materials used to construct steps, banisters, and handrails.

Due to the nature of the subject, photos of stairs often follow strict compositional rules. The steady rhythm of the horizontal lines at the edges of individual steps is complemented by the additional rhythm of the vertical lines of the handrail. Handrails also provide their own rising or falling diagonals. Steps and banisters can form slanting patterns within the frame, depending on the photographer's viewpoint. If you tip your camera upward or downward, you can create an image in which none of the straight lines in the subject are parallel to the edges of the image. Depending

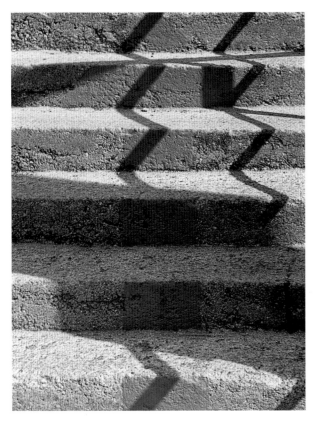

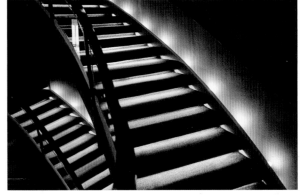

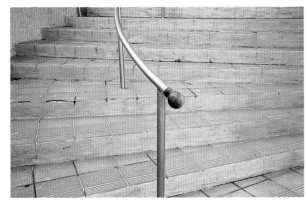

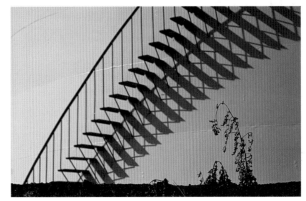

on its steepness, a free-standing staircase can also be dominated by diagonal or slanting lines. These strict forms can usually be diluted by including elements of color, light and shade, changes in color, or other distracting details.

Outdoor stairs are usually well lit, but interior stairs are more difficult to photograph effectively. Wide-angle lenses often produce interesting, exaggerated perspective, especially in cramped spaces such as stairwells. However, artificial light often causes unwanted color casts. A set of stairs can consist of just a couple of steps or cover the height of an entire building. People tend to associate the word "stair" with an upward movement, and photos looking down staircases are rare. Stairs too, can have their own sub-themes—such as "people on stairs"—and can be made more dynamic if you include deliberate motion blur.

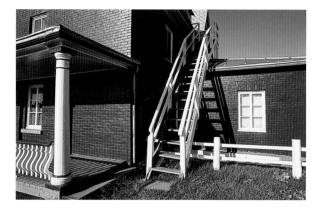

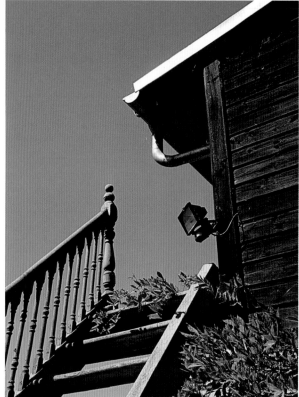

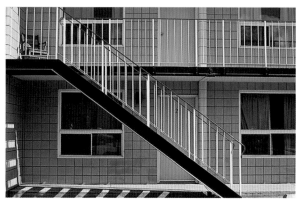

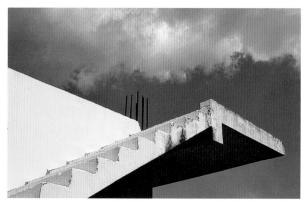

About the Photos

Shadow play creates additional tension in #2 and #5, while #1 and #3 show that intense colors can have a more dramatic effect than the actual content of an image. Full-frame outdoor stairs, as in #6 and #7, or in detail, as in photos #10, 11, and 12, don't always divulge the stairs' real purpose. The indoor shots in photos #4, 13, and 14 all present views looking down and are variously lit by the sun and artificial light. The way the stairs in #8 and #9 lead nowhere gives both shots a surreal feel.

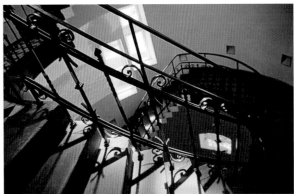

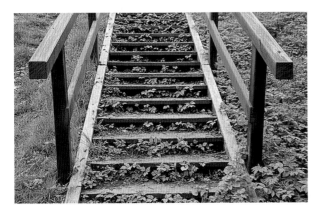

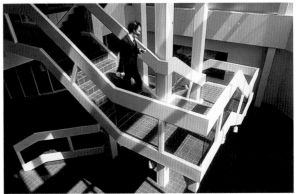

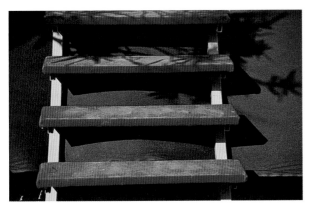

3 Tables and Chairs

Familiar Workaday Objects

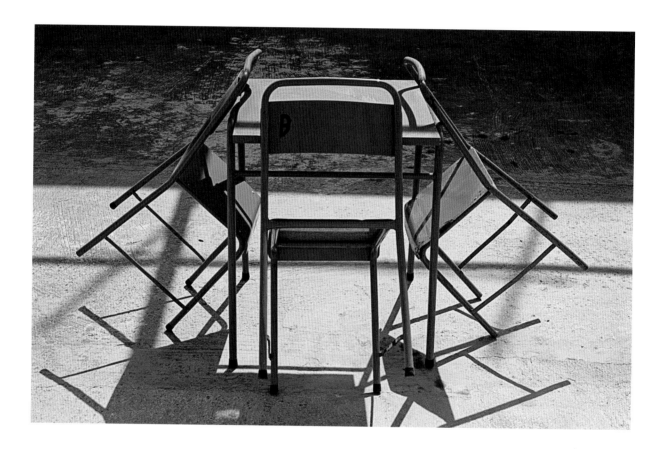

All visual artists try to use their chosen image format to the full. This generally means that the positive form of the main subject is placed as dominantly as possible within the frame. Empty space between the subject and the edges of the frame provides contrasting negative form. A single-color tabletop against a plain background is a good example of this effect. Photographing a rectangular subject using a rectangular format (or a square subject using a square format) produces a reduced-size repeat of the basic image shape within the image itself. However, tension only arises if the shapes within an image are different from the background, such as a circular table photographed using a rectangular format.

If a subject is portrayed up close, but without significant cropping of its basic shape, the viewer will not feel the need for the subject to extend beyond the edges of the frame. If, however, a subject's form is cut short by tight framing, the viewer will apply visual experience to produce imaginary extensions of it outside the image area. Subsidiary objects such as ashtrays, bottles, or cups enrich our *Tables and*

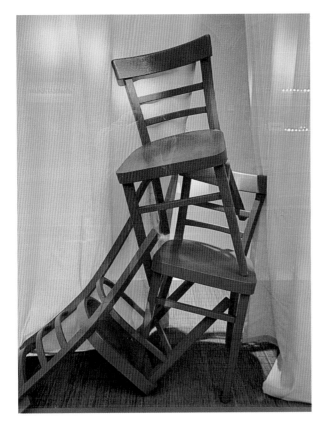

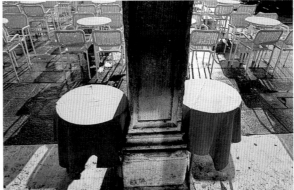

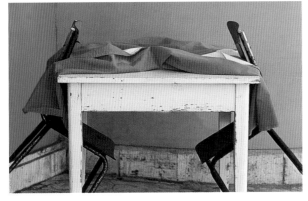

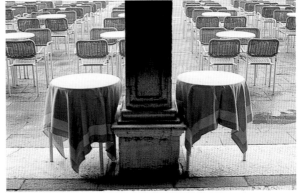

Chairs theme and lead us almost automatically to the subtheme of the set table, which anticipates the arrival of invited or uninvited guests. Set tables can be observed in orderly "before" or chaotic "after" situations, the latter perhaps following a party.

The formal "point" aspect of composition only plays a role if objects are placed on a table. Otherwise, shapes and lines will be the dominant factors in table images. Tabletops and the seats of chairs produce interplay between positive and negative form, while large numbers of chair backs and table legs can produce a confusing visual tangle with many smaller shapes formed by the intersections of the lines they produce.

While the forms of tables and chairs are largely similar, the range of colors within the theme is enormous. Table and chair photos often contain colors that contrast or harmonize with the active dominant color, as well as secondary colors that appear in shadows or other, less obvious image areas. Monochromatic earth tones—such as ochre, olive green, or jeweler's red—make interesting table shots.

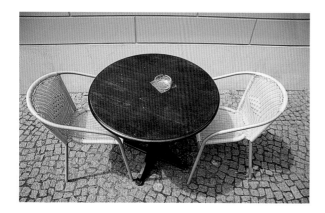

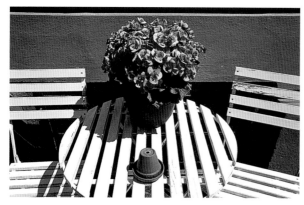

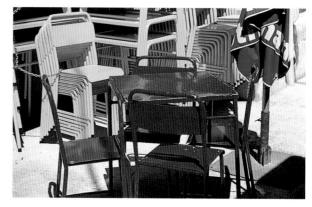

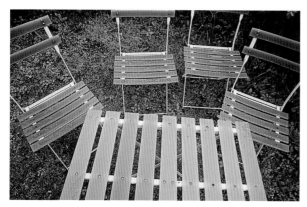

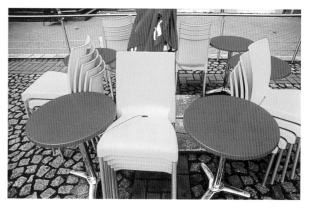

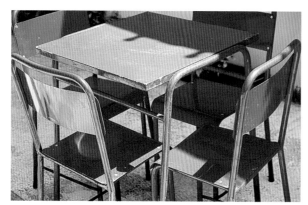

Under ideal lighting conditions, shadows can also produce interesting graphic elements in table and chair photos.

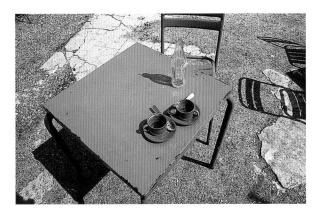

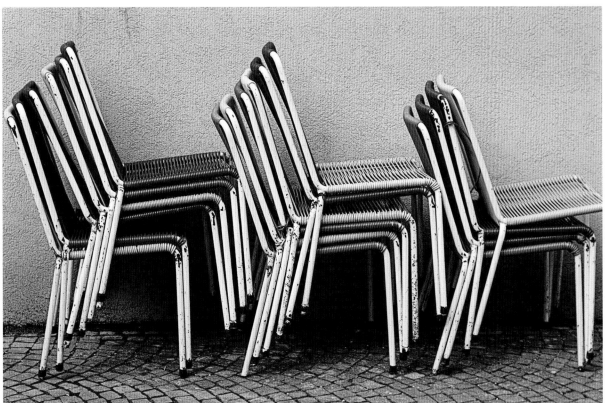

About the Photos

Whether they are circular, square, or rectangular, and whether they are pictured with or without chairs, a series is the perfect way to display pictures of tables. If you have sufficient material, you can arrange your images into groups of circular (#4, 5, 6, 7, and 11) or square tables (#1, 3, 8, 9, 10, and 12). Other subgroups could include a table with one chair (#12), with two chairs (#3, 6, and 7), or with four or more chairs (#8, 9, and 10). You can also group chairs on their own (#2 and #13) or collections of more or less arranged chairs, as illustrated in photos #2, 10, 11, and 13.

4 Brushes

Turning an Ordinary Object into a Photographic Subject

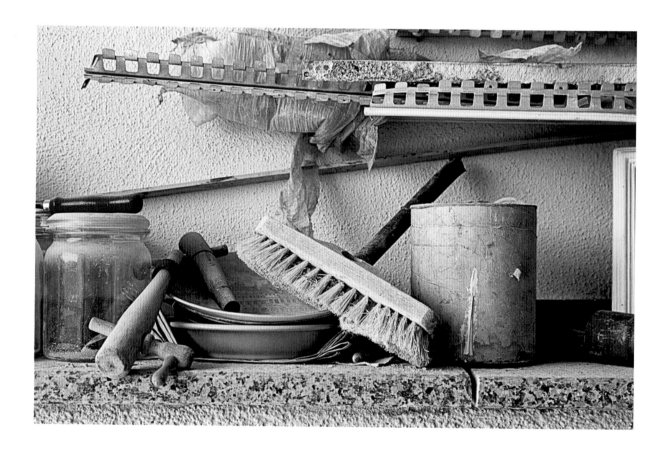

There are many tools and objects that we use every day but pay little attention to, including various types of household brushes. If you keep your eyes peeled on your travels, you will find that many countries have their very own brush culture.

Serial photos are especially gripping if they are related by multiple characteristics that include not only an overriding common theme, but also repeating colors or patterns.

Most brushes consist of a long, thin handle and a rectangular block with natural (or plastic) bristles attached to one end. This means that photos of brushes are related to each other not only through their common theme, but also through the repetition of point and line elements. These then relate to the space necessary to every visual composition. The brush handle will usually form the dominant straight line, whether this is vertical, horizontal, or a diagonal. If a line divides a surface, it suddenly possesses the power to form new shapes. Brush handles rarely intersect with the edges of an image, and are thus less likely to play a significant role in the basic distribution of shapes within the frame.

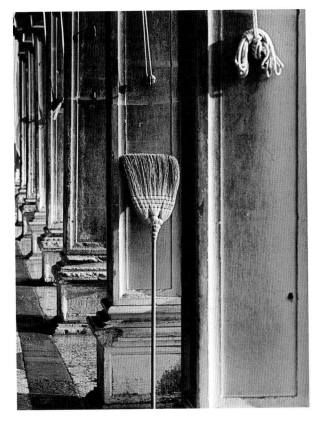

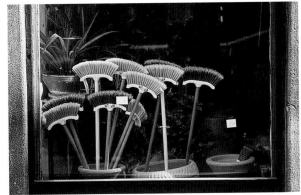

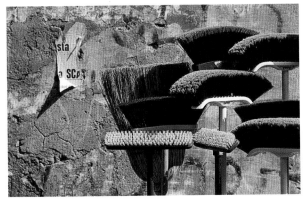

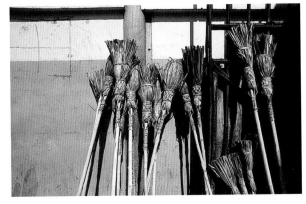

Brush handles are usually made of untreated wood and have little influence on the overall color scheme in an image. On the other hand, bristles nowadays are often made of plastic, providing a wide range of bright colors that can affect the overall look of an image. The special interplay between point and line in brush photos can lead to interesting challenges to the balance within an image. Everyone immediately recognizes a brush, even if an image contains other distractions. A brush can also belong to larger groups of mixed objects, making it less likely to be seen as the main subject.

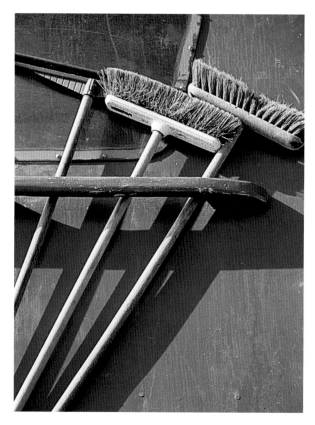

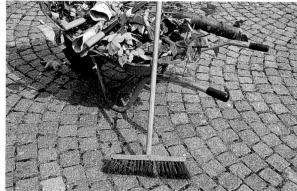

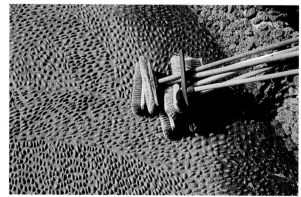

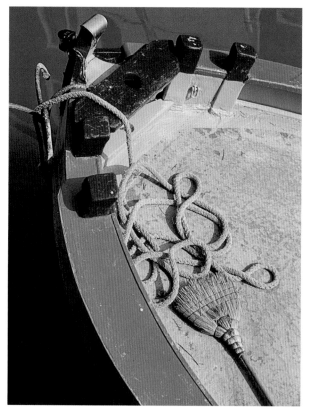

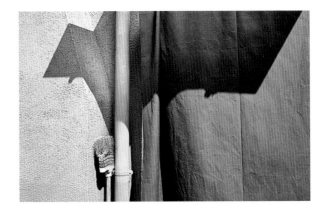

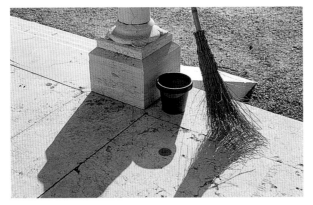

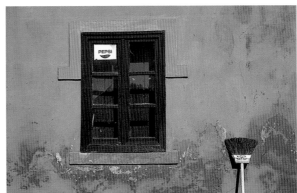

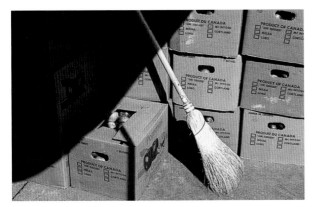

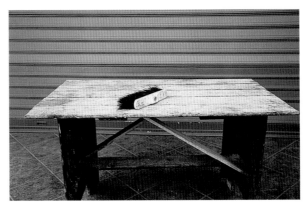

About the Photos

Brushes are usually found in corners or standing against a wall. This means that their handles are normally positioned either vertically or diagonally. Single brushes, like the ones in photos #2, 8, 10, and 11, dominate the composition, whereas multiple brushes, such as the ones in photos #4, 5, 6, and 7, invite the viewer to compare the different angles they produce. Photo #7 only infers a diagonal, although the inference is very strong.

Close-up details, like the ones in photos #3, 4, 12, 13, and 14, give the viewer an impression of single or grouped points rather than lines. Photos #1 and #9 show how quickly a brush can lose its dominance to competing objects within the frame.

5 At the Market

The Fine Line Between "Dumped on the Floor" and Works of Everyday Art

Markets provide a wide range of visual themes and photographic opportunities. Capturing communication among people from close up is often tricky, and is especially difficult in the context of a busy market. Background color and contrast are constantly changing while you wait for the perfect moment to take your shot. Once you learn to recognize the elements that spoil an otherwise good composition, you will begin to develop a sixth sense for background irritations while they are happening, even if you are concentrating on action that is taking place elsewhere.

Portraits of stall-holders are easier to take, and you can often get unspoken permission to shoot using eye contact. If you shoot a series of images of a person, common decency dictates that you ask if your subject would like to receive prints of your results. Apart from potentially distracting lighting, taking photos of fruit and vegetables doesn't present any serious technical challenges. This chapter deals with the presentation of wares as part of the overall market theme.

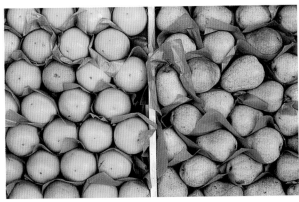

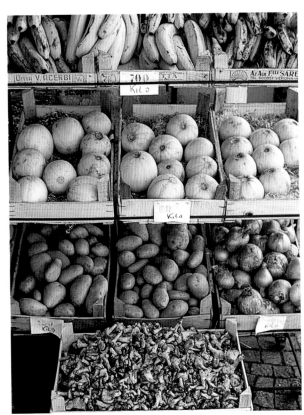

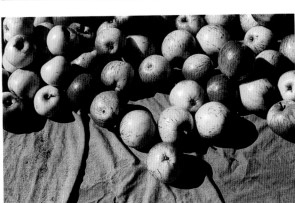

A newspaper, a sack, or a wooden crate are the simplest possible market stalls. While a crate is generally low-key, newspaper print or a printed pattern on a piece of cloth can end up competing for the viewer's attention with the goods on display. A close-up of the way goods are presented can often tell us more about the character of the person doing the selling than a general view that includes the person in the composition.

An important element of market shots is the formal structure of the stall, which can be dominated by contrasting colors or, in close-up, single colors. A single, simple image of a particular sort of vegetable is in itself of limited interest, but nevertheless comes into its own in the context of a photo series covering a common theme. The varying colors and forms of a market could, for example, be presented as "Market Textures".

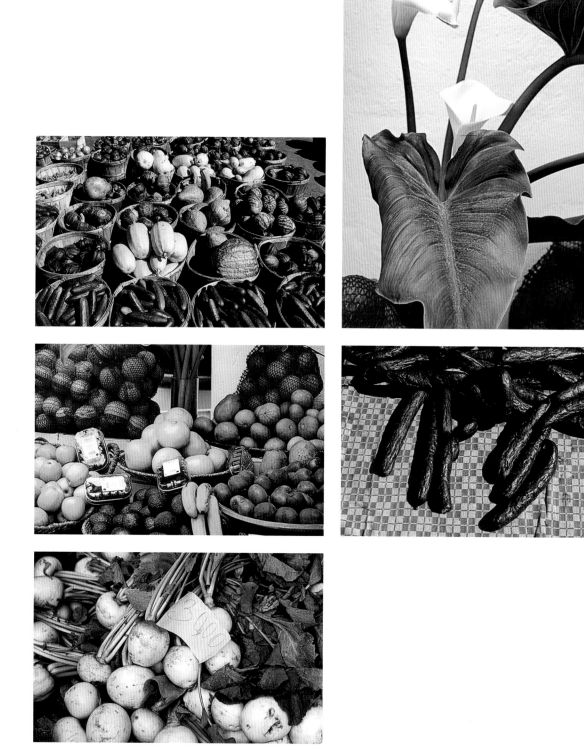

About the Photos

It is tempting to try to read the newspaper articles in images #1 and #11. The blue checkered cloth in #10 provides an interesting color contrast to the sausages on offer, while the cloth in #12 can probably best be described as "quaint." Photos #2, 6, 7, and 9 illustrate how artistically some stall-holders arrange their wares, while #4 and #5 show how monochromatic similar-looking objects can become. Photos #3, 4, 8, and 9 illustrate the effectiveness of contrasting colors, while #6 and #7 demonstrate the charm of multiple colors within a single still life.

6 Plastic

Bright and Virtually Indestructible

The plastic goods flooding the market have, in many cases, supplanted more traditional materials such as wood, glass, and metal. Whether we like it or not, cheap goods are nowadays socially acceptable, and the bright, mass-produced world of plastic products is here to stay. Plastic products are not only cheaper, but often more practical than enamel buckets, zinc watering cans, tin dustpans, glass bottles, or rubber airbeds. Opinion is divided on whether so much color is a good thing, but regardless of who decides which colors suit what products and irrespective of who buys all this stuff, mountains of plastic goods are now part of our everyday life.

The contrast between the individual colors of different products is extremely eye-catching. Yellow plastic appears to positively radiate brightness, and green watering cans often outdo all natural shades of green. The images on these pages illustrate small, everyday objects, although plastic is used to construct larger objects such as wading pools, boats, and even cars.

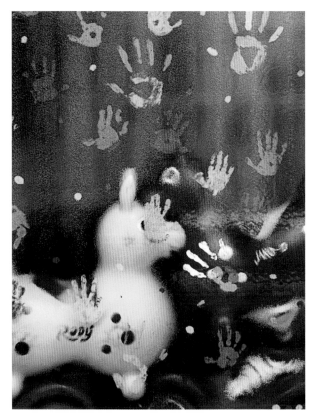

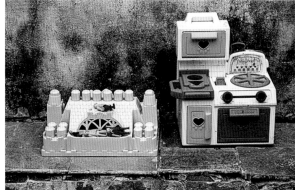

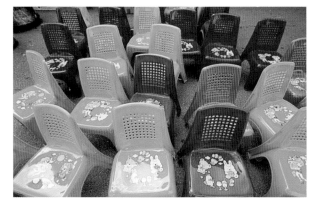

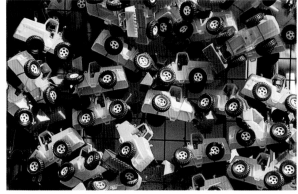

Generally, plastic products are seen as a cheap alternative to objects made of more valuable materials. This is true to a certain degree, but it doesn't do justice to the real story behind the advent of modern plastics. Chemists produced the first usable plastic products in the middle of the 19th century, and since then more than 600 different plastics have been patented. Plastics have hundreds of uses in industry, the building trade, and household applications, as well as the world of art and jewelry manufacture.

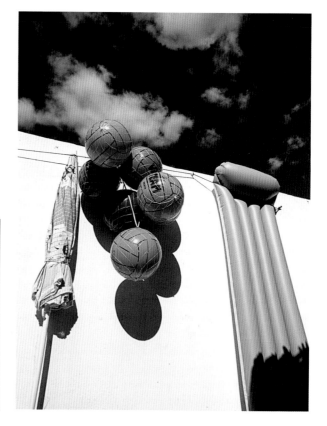

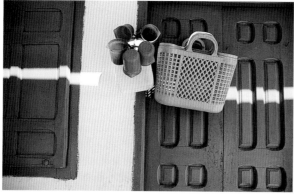

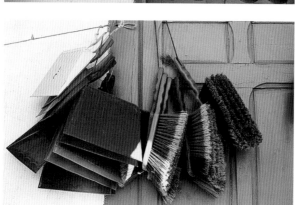

About the Photos

Traders try to attract potential customers with the sheer amount of products they offer. Photos #1, 3, and 5 are images shot at Mediterranean markets. The small size of the individual objects creates texture, and the brightest colors are usually found among stalls selling household goods, toys, and beach articles. The large, single-color surfaces of airbeds makes them obvious subjects (#8 and #9), while the household goods in photos #6, 7, 10, 11, 12, and 13 are conspicuous in the variety of their shapes and colors. Plastic goods are impervious to bad weather and don't have to be quickly cleared away if it rains. They aren't easily damaged if they are left outside by mistake, as in #4.

Image #2 shows the window of a playschool. The intense colors of the plastic animals are in direct contrast to the children's hand prints on the window glass.

7 Balloons

A Multitude of Semi-transparent Shapes

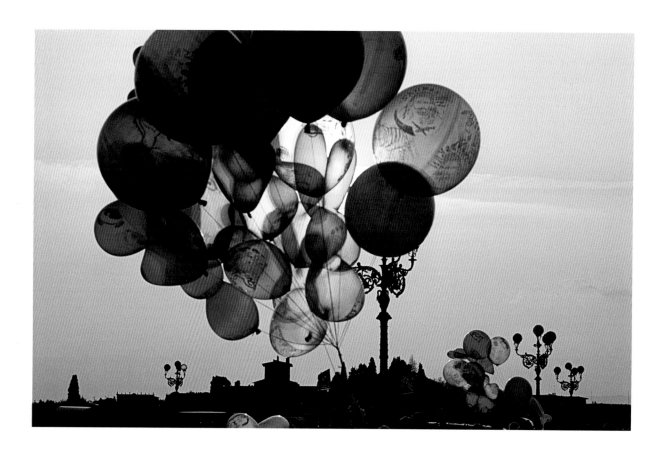

Traditional balloons made of thin, semi-transparent rubber are of a roughly spherical shape, in spite of the slightly oval form of the tied-off end. Three-dimensional objects are reduced to the sum of their width and their height when they are portrayed in two dimensions, accentuating the circular effect of balls and balloons in photographs.

Alongside squares and triangles, circles are the third major shape recognized by basic design theory. These shapes can be transformed into other, similar shapes. For instance, a square shares four right-angled corners with a rectangle, just as an oval follows the same basic curved line as a circle. Most photographs are shot using a rectangular format, giving rectangular subjects an obvious visual relation to this format. The shapes of all other subjects contrast with the shape of the image frame. Because we are used to observing the content of an image rather than its form, most viewers are not conscious of the shape of the image itself. It is only once an image has been reduced to a simple, two-color foreground/background composition that it becomes obvious to the untrained eye that there is tension between

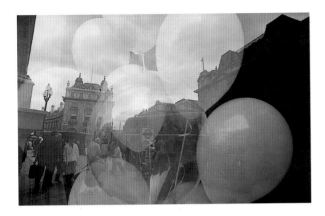

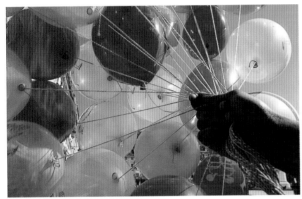

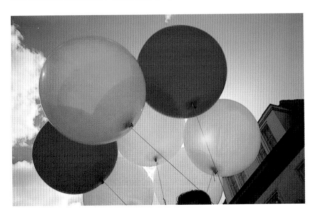

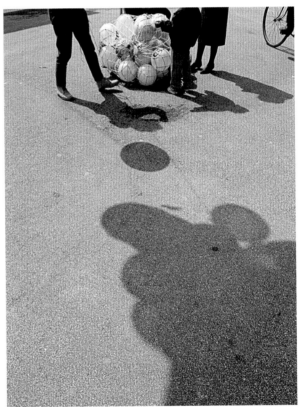

the subject and the shape of the frame. Signs and symbolic designs make use of this effect—examples are the Japanese flag with its red circle on a white rectangle, or the white rectangle and red circle of a *No Entry* sign.

Balloons make a more dynamic subject when they are grouped together, forming circles, semicircles, and arcs. Other shapes are also formed when tight framing causes a balloon to be foreshortened by the edge of the frame. Viewers have no trouble completing a circle cut off this way in their minds.

Balloons are traditionally single-colored, so the look of many balloon photos is defined by the contrast between clearly defined (colored) shapes. Primary colors (blue, yellow, and red) and secondary colors (orange, green, and violet) provide the strongest contrast. In addition to direct light, backlight especially emphasizes the transparency as well as the shape of balloons.

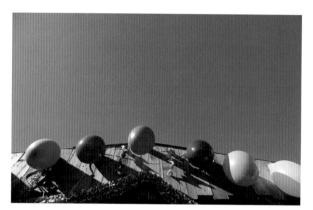

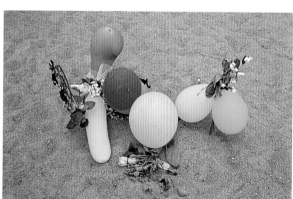

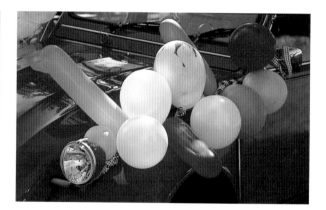

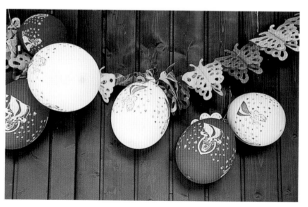

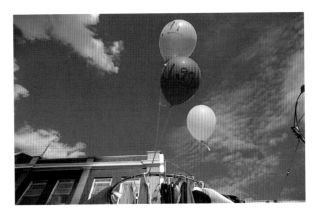

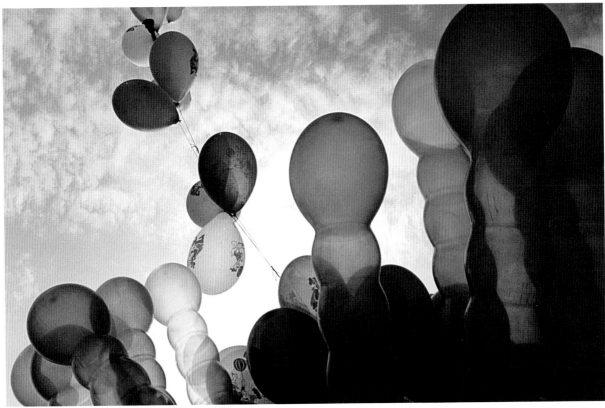

About the Photos

Wide-angle lenses are great for shooting bunches of balloons. The evening light in #1 produces a warm overall tone, while photos #6, 11, and 12 produce greater contrast between the blue of the sky and the balloons themselves. Balloons are often present at children's parties (#6, 7, and 10) or weddings (#9). The balloons in #8 were photographed after a party. Photos #2, 3, and 4 show both tight crops and transparency effects. Ironically, #5 doesn't include any balloons at all—the actual subject is the bag of footballs, while the balloons are merely inferred by their colored shadows.

8 Umbrellas and Sunshades

Decorative Protection from the Sun and the Rain

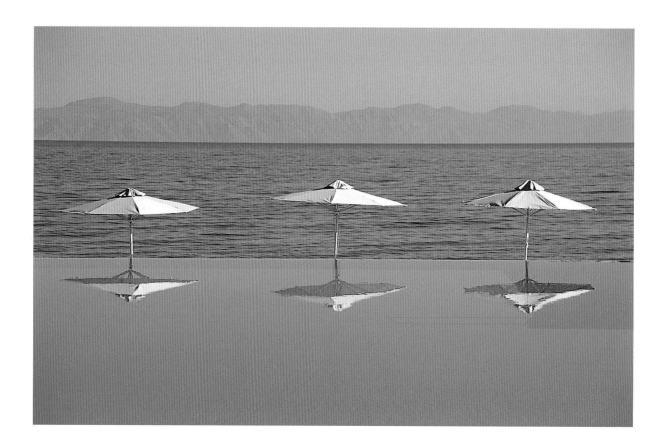

These two very similar objects represent two diametrically opposed weather conditions, and accordingly, two different approaches to taking photos. A closed sunshade is seldom decorative enough to warrant a photo and is only opened when the sun is too strong. Apart from the private sunshades used at the beach, most sunshades are found in a fixed position, making the immediate environment the biggest challenge to effective composition.

Sunshades are found not only in picturesque settings at the ocean or near a pool, but also in industrial areas or markets, where they are often closely bunched. If you are lucky, you can find a raised shooting position that allows you to take interesting photos of your subject's colors and shapes.

In contrast to sunshades, umbrellas are highly portable. Closed umbrellas only make good photos when they are grouped in an umbrella stand or a shop. On the other hand, open umbrellas are an important design element in everyday street scenery. Apart from the occasions when umbrellas are used—usually by women—as sunshades, they are associated exclusively with inclement weather.

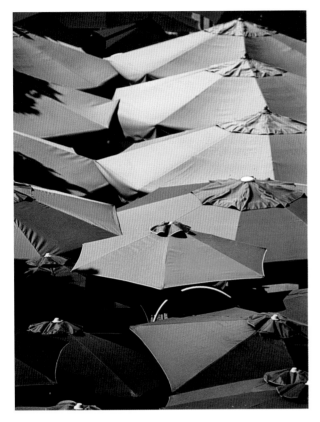

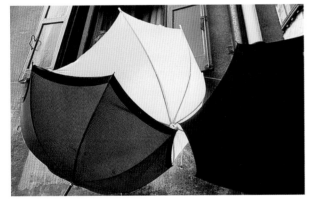

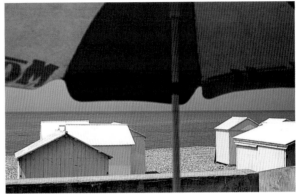

Umbrellas move passively with the help of people, making shots that include blurred shapes and colors an interesting alternative. There is usually less light available when it is raining, so longer shutter speeds and camera pans are often the only surefire way of capturing a shot anyway.

Umbrellas and sunshades have the same, single-line shape when they are closed and form a curtailed semicircle when they open and are viewed from the side. Viewed from above or below, they present circular forms. The shape of an umbrella also includes bundled verticals radiating out-

wards from the tip. The main differences between individual sunshades and umbrellas are caused by the different patterned materials they are made from. Contrasting colored panels are often placed next to each other, making single-tone triangles an additional visual element within the umbrella theme.

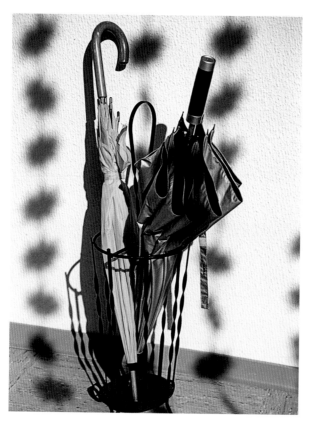

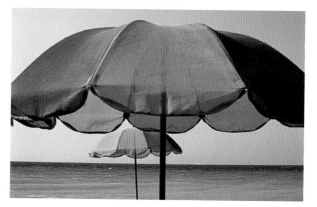

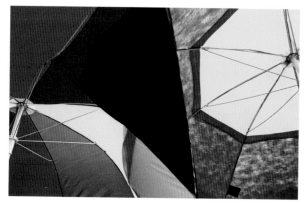

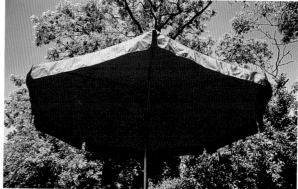

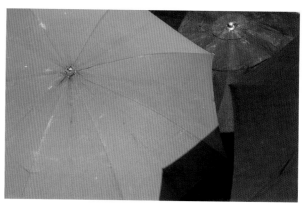

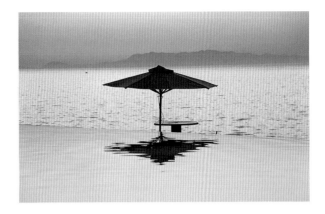

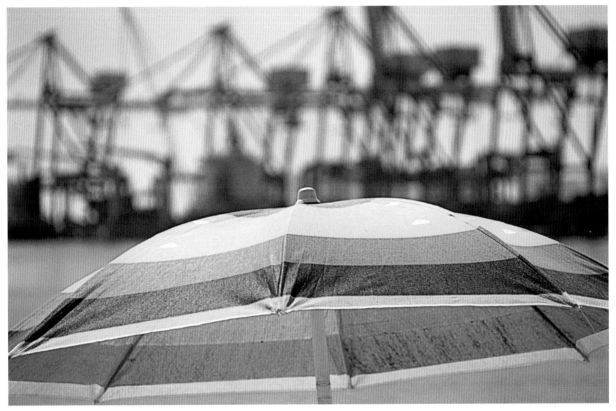

About the Photos

On vacation, you can often find special sunshade images if you manage to capture the right moment, as in #1 and #11. Interesting large/small contrasts can be found at the beach (#9). The raised view of market sunshades in #2 and #10 include multicolored elements, while #10 also displays the more complex interplay caused by contrasting bright and achromatic colors. Photos #4 and #8 are simple, calm views from below, while #7 shows an extremely lively mixture of colors and triangular forms. Photos #3 and #5 display very muted colors. The surroundings in photos #4, 6, and 11 include important clues that help tell the story behind the image.

9 Water

The Elixir of Life—Simultaneously Gentle and Threatening

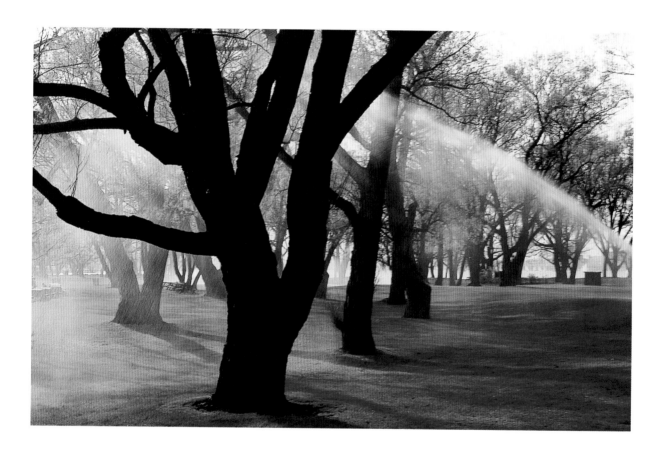

Every search for photographic subjects leads sooner or later to the four elements. *Earth*, *Fire*, and *Water* offer an almost limitless range of opportunities, while *Air* is a more difficult theme to address visually. Earth is ubiquitous on land, fire is often a bringer of danger, and water is generally perceived as the fount of all life. A photo series that addresses water's gentle side can quickly turn up a number of sub-themes that are wide-ranging enough to become main themes of their own, such as streams, rivers, waterfalls, the ocean, or even rain, with its accompanying puddles and raindrops.

Wind brings movement, and thus texture, to the otherwise smooth surfaces of seas or lakes. Water also plays a significant role in public life, in the form of fountains, ornamental pools, and irrigation systems for public parks. In a private context, water can be found in garden ponds, wading pools, private swimming pools, and watering systems. Faucets, basins, and watering cans are just some of the many peripheral objects that are associated with water and that form a part of the overall theme.

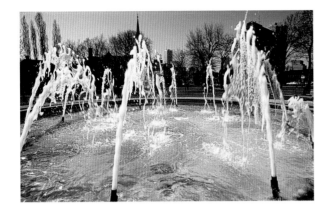

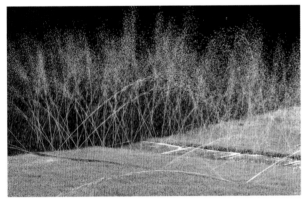

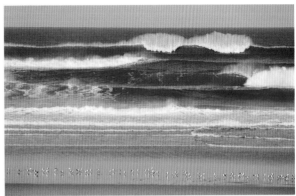

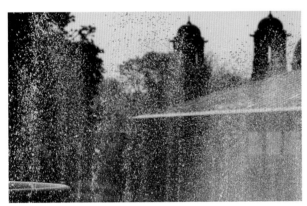

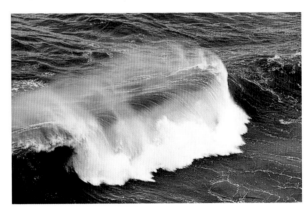

Broadly speaking, clouds also belong to the water theme in their role as part of the cycle of evaporation, condensation, and rainfall. Condensation on window panes makes a fascinating photographic subject, especially when there are considerable temperature differences between the two sides of the glass—for example, in kitchens or florists' stores. Water itself is colorless, but particles of earth in streams and rivers give it earthy tones, while sunlight lends the ocean a turquoise color—not just in the Caribbean. Swimming pools are often painted blue to artificially enhance this effect. Still water is clear and indiscernible, and only becomes visible when it reflects its surroundings.

Moving water is, paradoxically, easiest to visualize if you "freeze" its movement—short shutter speeds are great for making individual droplets appear to float in the air. Individual droplets are no longer visible and appear blurred or misty in sweeping panoramas or shots taken using telephoto lenses.

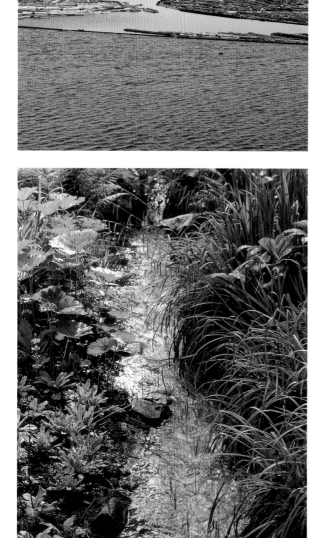

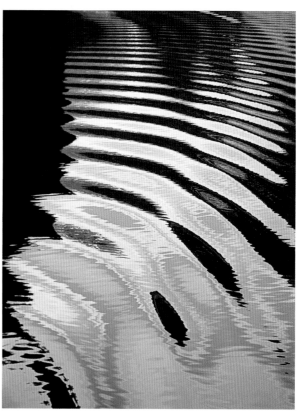

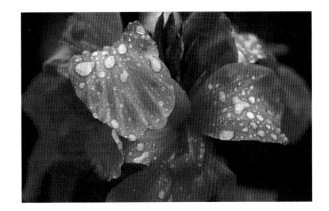

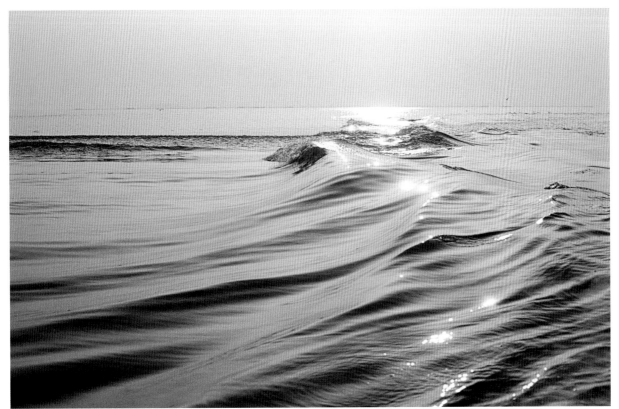

About the Photos

The ocean can be portrayed either with its elemental force, as in #5 and #6, or with the calm associated with fjords, Venice, or the Maldives (photos #9, 10, and 12). Smooth surfaces are best for reflecting the blue of sky (#7), while streams like the one in #8 often appear to have a special color of their own. Photos #1, 2, 3, and 4 show public and private watering systems. And this section wouldn't be complete without a shot of water drops on a flower (#11).

10 Boats

For Work or Pleasure

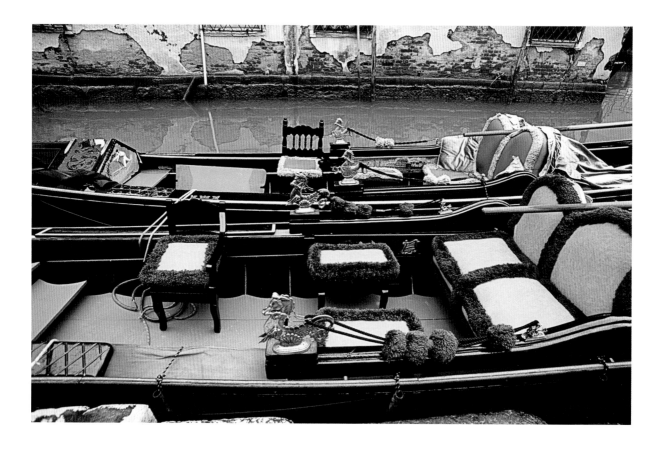

Rafts, boats and ships are among the oldest forms of transportation built by mankind. The broad spectrum offered by the boat/ship theme includes freighters, cruise ships, research ships, container ships, and a variety of specialty variations such as steamers, schooners, ferries, tankers, and barges—to name but a few.

The dugout canoes and reed boats of early civilization, followed by the Viking longboats and the sailing ships of the great seafaring nations, have all contributed to some of the major myths and discoveries in human history. Sport boats, pleasure boats, and working boats can be found in harbors and on islands, as well on rivers, lakes, and reservoirs all over the world. These include fishing boats, rowing boats, sailboats, motorboats, glass-bottomed boats, paddle boats, canoes, dinghies, and gondolas. Gondolas especially represent the pinnacle of a boat-building tradition that still enjoys a special relationship with the city of Venice. The sheer elegance of modern gondolas, with their graceful shape, their polished woodwork, and their sumptuous decoration, almost overshadows their actual purpose, which is

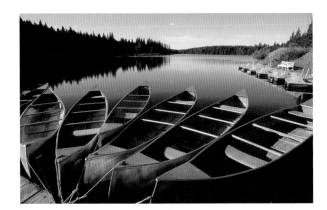

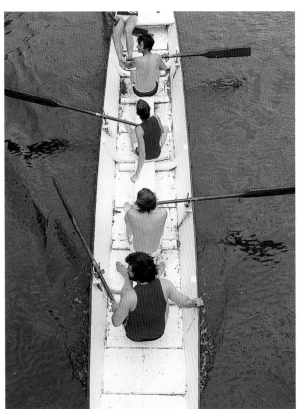

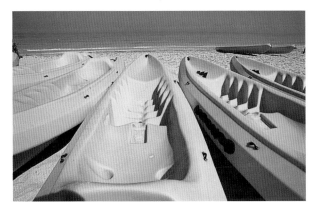

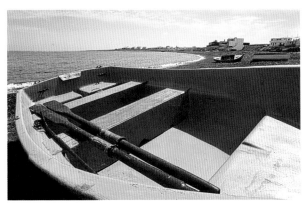

to transport people from one place to another. After all, the same job can be performed just as well by a tub made of ordinary planks.

While large ships usually serve purely technical purposes, small boats can often be portrayed as part of a natural scene. Once viewers recognize the subject of an image, they react to it according to their previous experience of similar situations. Photos of boats often remind us of our vacations or travel. Romantic landscapes that include boats immediately produce these types of feelings, while detailed

crops of a boat give us hints but don't always cause us to recall memories directly.

The color of water, ranging from cool, greeny blues to warmer turquoise tones, is often the dominant color in boat photos. Boats and boat details themselves provide colors that are complementary or contrasting. The generally elongated shapes of boats form horizontal or diagonal lines within the frame. Boats that are portrayed to cover a relatively small part of the frame—but which possess an active

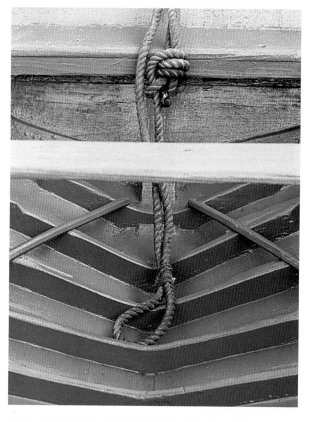

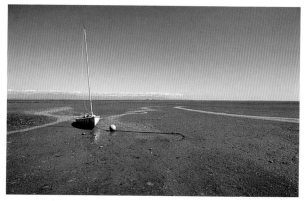

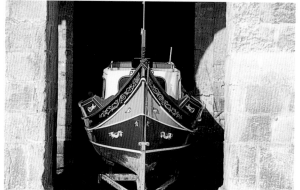

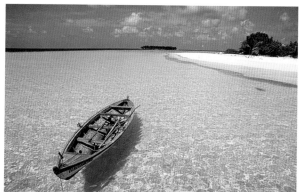

or obviously bright color—usually form the dominant point within a composition.

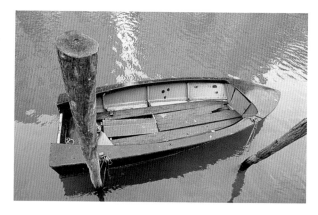

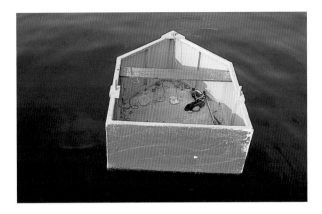

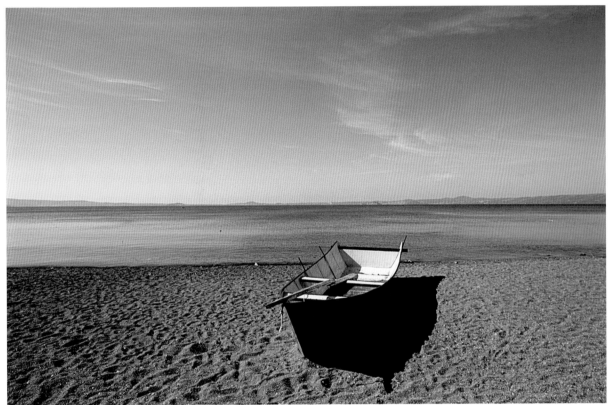

About the Photos

Photos #1 and #7 illustrate traditional splendor, photographed in Venice and Malta. Photos #2, 3, and 4 show boats made of metal, plastic, and wood. Photos #8, 9, and 12 demonstrate the principle of a small boat dominating a composition. Photos #10 and #11 show the very simplest of boats. Photo #6 is also recognizable as a boat in spite of the very tight crop. In this case, my vantage point on a bridge allowed me to take a vertical, portrait-format shot.

11 Laundry

Between Art and Necessity

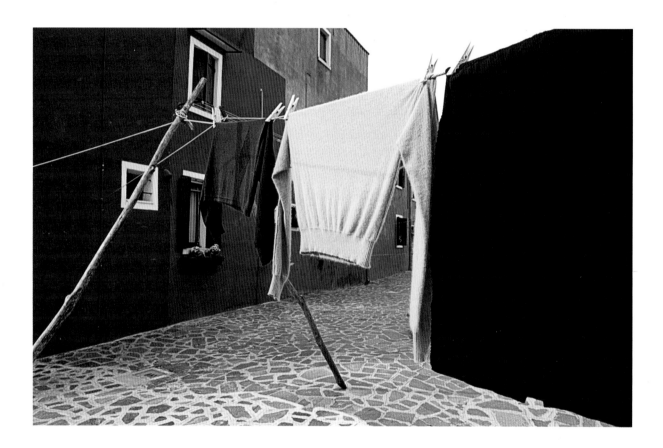

Images and image details often inspire an observer to make up stories about the objects being observed. The nature of these stories will, of course, depend on the observer's own experiences. Because mankind has interfered in just about every conceivable aspect of life, it is only natural that such stories usually end up including people. The *Laundry* theme is a subject close to people's hearts and provides a lot of scope for inventing stories. Photos of laundry generally lead us to think about people with little or no money. Rich peo-

ple's laundry is not a public subject and is not hung out for all to see.

Laundry that is hung out to dry in an urban context reminds me of warmer, often Mediterranean countries, and includes some larger cities like Florence, Naples, Lisbon, and Valetta. Even Burano (near Venice) and Venice itself offer many opportunities for capturing picturesque memories. The endless cycle of wearing and washing that transforms a piece of new clothing is only inferred, but is not visible, in photos. Textiles often end up as shoe rags or kitchen

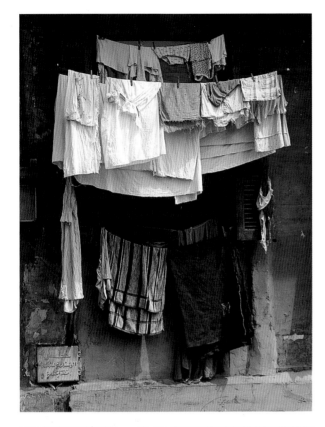

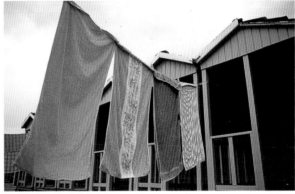

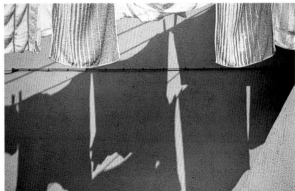

cloths, although even these have to be washed and hung out to dry.

The forms found in photos of laundry are highly traditional. Washing lines form lines, clothes pegs form colored points, and the laundry itself forms shapes that dominate nearly every photo. Differences in size between sheets, tablecloths, dresses, socks, or washcloths provide visual contrast, while an observant viewer can see and capture the diferences in color and shape between apparently similar items of clothing. Laundry blown by the wind also

provides interesting visual counterpoints. The shapes and colors of individual pieces of laundry always offer plenty of contrasting subject material.

Light and shade, as well as incidental light are important aspects of composition in this context. Lateral light emphasizes the folds of the materials, while strong backlight underscores the strength of the colors. Washing and drying laundry is a much broader-ranging subject than we can effectively illustrate here. In regions where laundry is still washed by hand in a washhouse or on a riverbank,

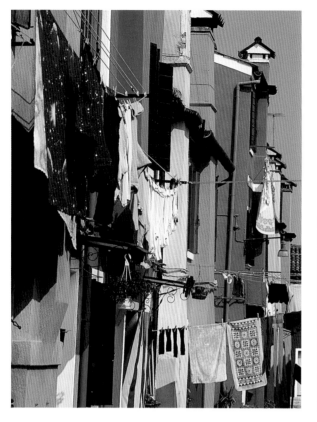

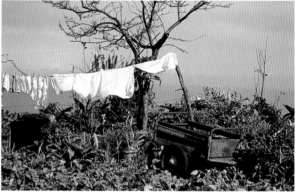

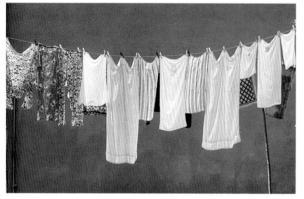

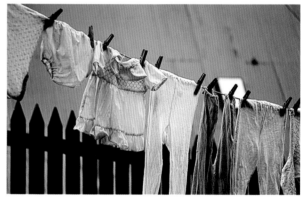

sheer hard work ends up displayed in photos that are often paradoxically interpreted as quaint or even folkloric.

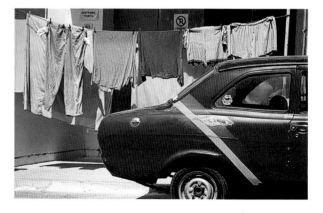

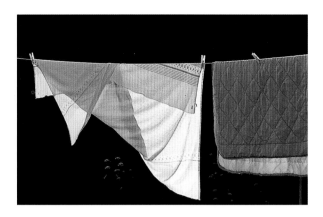

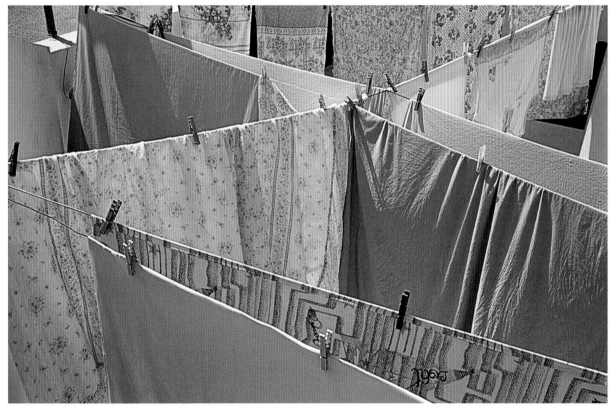

About the Photos

Photos #1, 6, 8, and 12 show that laundry, often in combination with its immediate surroundings, can provide fascinating color contrasts. Laundry in the city (#2 and #10), on the beach (#4), or in the country (#8 and #9) always tells a story about people. Backlight and shadow provide the main attraction in photos #3, 5, and 11.

12 Traffic Mirrors

Points of Interest in Town and Country

Deciding how to position important shapes within an image is a fundamental aspect of the process of composition. Not only does the object itself have a shape, but the space surrounding it also has its own "negative" shape. Traffic mirrors are usually either rectangular or circular and are usually slightly convex. The traditional 35mm, 2:3 shooting format is still widely used and can cause compositional problems when you photograph traffic mirrors. Portraying a rectangular object within a rectangular frame produces a simple repeat pattern, and the only decision you have to

make concerns the degree to which the mirror fills the frame, either providing or hiding additional background information.

Balancing a composition in which a circular mirror is placed within a rectangular frame can be more difficult. If you want to show the entire circle without cropping it, at least a third of the area within the frame will not be taken up by the subject. A circular mirror is easier to photograph if it is free-standing with the sky in the background. If this is the case, make sure the areas to the left and right of the

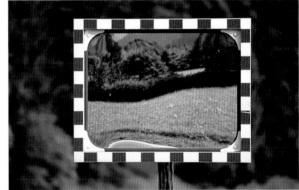

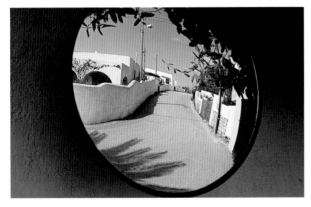

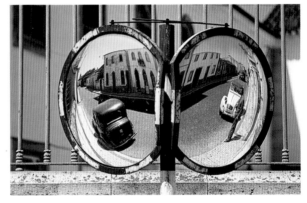

mirror are of equal size, as areas of differing sizes almost always produce unnecessary tension. If you photograph a circular mirror to fill the frame, you will have to crop its edges.

Traffic mirrors are designed to help you see around corners and are often mounted on striped or checked backgrounds to avoid the viewer confusing mirrored information with the visual information provided by the mirror's immediate surroundings. The combination of bright and active colors is optically very conspicuous, making traffic

mirrors extremely eye-catching. Opposites and contrasts are important parts of the message delivered by images on mirrors. A mirror enables you to look in both directions and simultaneously to focus close-up and in the distance. You can influence the effect of the "picture-in-picture" aspect of mirror images by taking care with your choice of shooting position and the focal length of your lens.

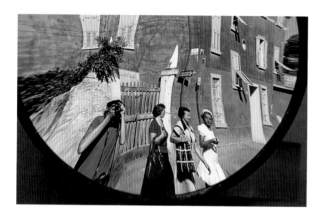

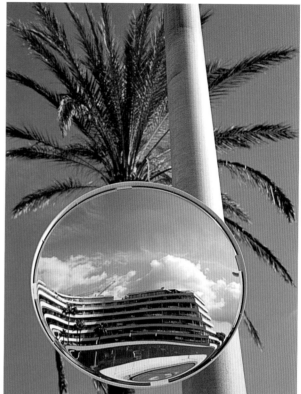

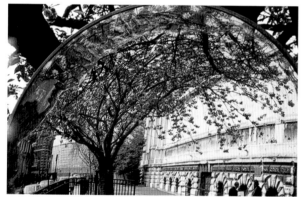

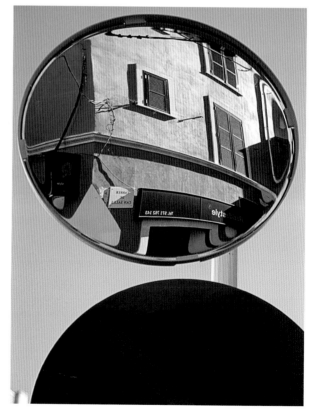

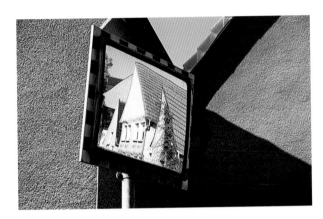

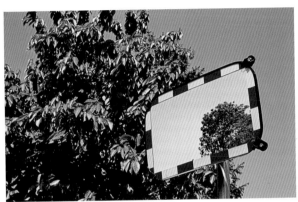

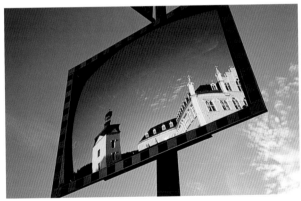

About the Photos

Photos #1, 2, 3, and 4 show how dark backgrounds can make images of mirrors especially effective. The twin mirrors in #5 could only be captured in a 2:3 format image because they are mounted at an angle. A single frame only has space to contain 1½ circles, as in #9. Photos #6 and #7 show clearly that you can only get closer to circular subjects if you are prepared to crop the basic shape, while the crop of a rectangular mirror in #13 was made for purely aesthetic reasons.

Photos #8, 10, 11, and 12 are interesting variations on the picture-in-picture subtheme.

13 Street Lamps

Practical and Decorative Features

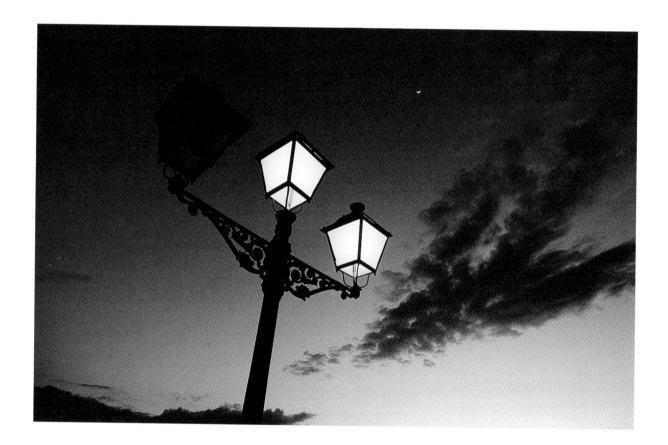

Street lamps address one of the central themes of photography: namely, light. A certain amount of light is necessary if you want to produce an image at all. Most analog films are designed to produce true color rendition in daylight, which has a color temperature of 5,400 K (Kelvin). Digital cameras can be set to work at the same color temperature, thus producing realistic-looking colors. Variations in color temperature settings produce color casts in the resulting images. Artificial light has a lower color temperature than daylight and thus produces warmer tones with a yellow or orange cast. You can work around this kind of color cast either by using a blue filter or by adjusting your camera's color temperature setting to a higher value.

The automatic flash units built into many of today's cameras often spoil the atmosphere in a photo by producing "hard" shadows, so a tripod and long shutter speeds are preferable for shooting at dusk. When street lamps are already lit but the remaining daylight still produces silhouettes, you can use these mixed light sources to produce interesting color images.

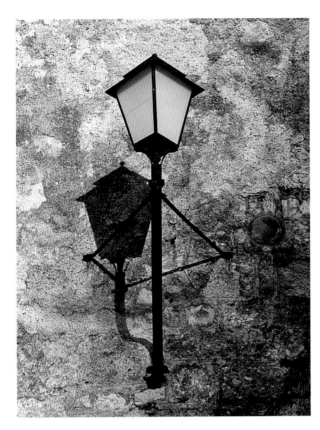

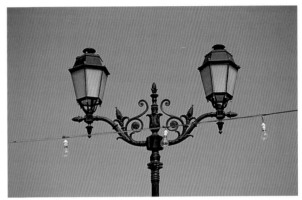

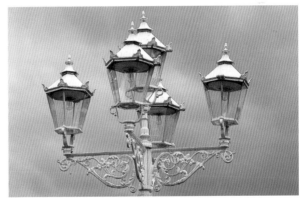

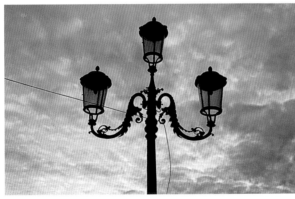

Street lamps don't offer a vast range of compositional variations, and they are often based on points or groups of points. Suggested and real lines of differing thicknesses also play a role. A single street lamp immediately becomes the dominant point within the frame, and all points, whether single or multiple, are joined to the lower edge of the frame by the lamp's central post. Images that don't adhere to this standard are guaranteed to interest the viewer more. A three-headed lamp in which one bulb is broken or a shadow

of a lamp that looks like a real, solid lamp are examples of effective deviations from the norm.

Different countries appear to have their own rules governing the shapes of their street lamps, making this another productive theme when you are travelling. Older street lamps often have attractive shapes and offer an interesting contrast to more modern forms. You can use this contrast within a series or simply stick to one type or the other. Apart from the very few occasions when artificial light adds unusual detail to a daylight scene, it is the shapes of street

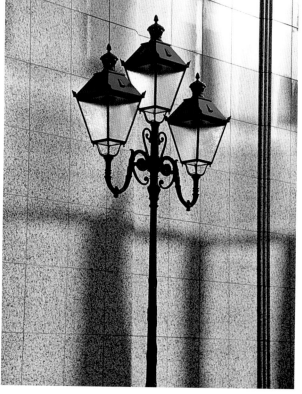

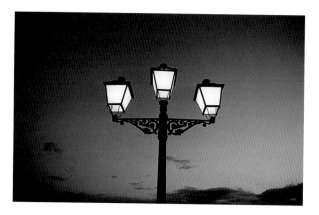

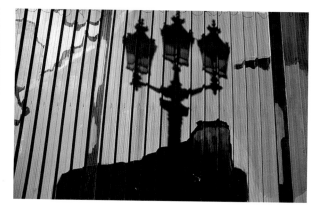

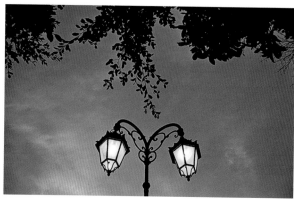

lamps that make them interesting to photograph during the day.

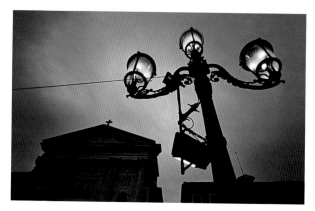

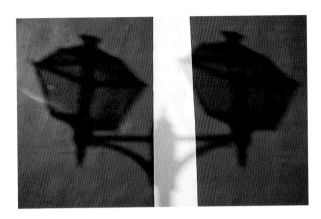

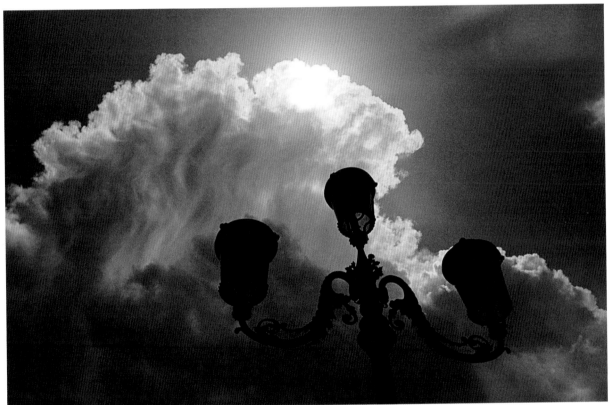

About the Photos

Dusk is by far the best time of day to take moody images of lit street lamps, as illustrated by photos #1, 6, 7, and 10. Photos #2, 3, 4, 5, 8, and 12 include several lighting variations, with compositions varying from a single point to a group of five street lamps. The shadow lamps in #9 and #11 are an interesting variation on the basic theme.

14 Light and Shade

Opposites United

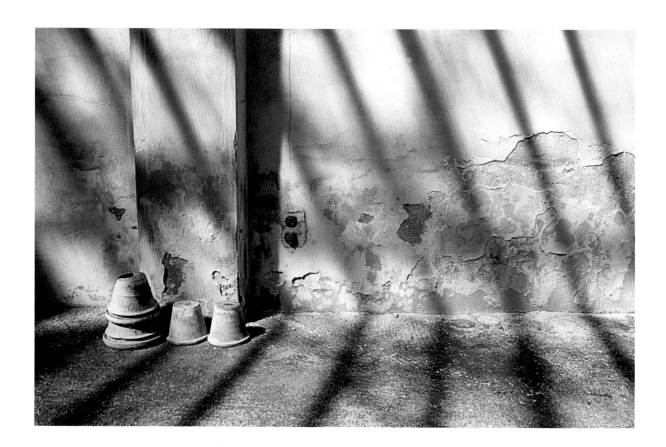

Subjects with obvious shadows provide a great opportunity to visualize the presence of light.

As long as a light source isn't part of the subject itself, it remains anonymous. However, our everyday experience of our surroundings, together with unusual color casts, make it possible for us to "recognize" a light source that is not actually visible in an image. Daylight analog film and appropriately adjusted digital cameras produce images without color casts, but as soon as a mixed or artificial light source is used, we see the difference it causes in the colors we see.

Light that comes from the side or that strikes a surface obliquely emphasizes bumps and textures, making the surface appear more tactile and alive.

Morning and evening shadows are longer and often more interesting. There are three main categories of shadow images: those that include the object that is throwing the shadow, those that include only part of the source of the shadow, and those in which the shadow's source is outside the frame. The first two types can produce surprising shadows, but it is usually clear what the subject is and how it is

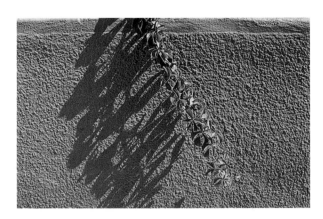

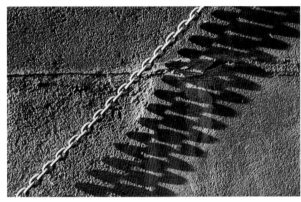

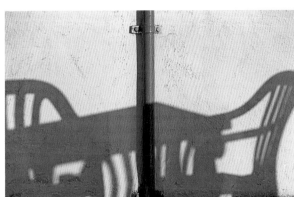

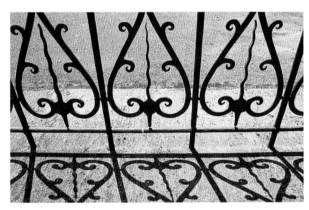

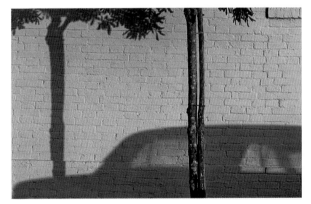

being lit. Images in the third category, in which external shadows are superimposed on other objects, often raise questions about the source of the shadows, making them more interesting and abstract.

The viewer's expectations regarding the shape of a shadow are usually confirmed in images in which an object and its shadow are both visible, although longer shadows and distortions can produce an optical surprise or two. Shadows are often shaped differently from their sources, and small subjects can produce surprisingly large shadows.

Conversely, if the sun is high in the sky, shadows often appear to be compressed. Sometimes, shadows can take on strange forms that make it impossible to tell which object produced them, especially if the image contains no reference to the object itself. Shadow shots don't usually require shutter speed corrections, but if shadows cover a majority of the frame, it can be necessary to use slight negative exposure compensation to ensure that you don't lose highlight detail.

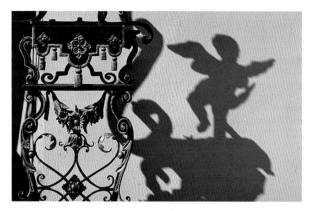

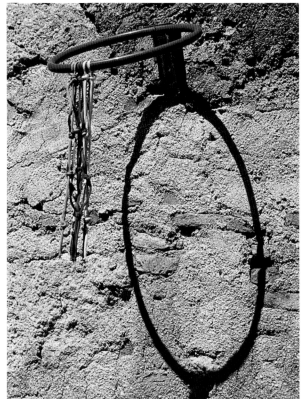

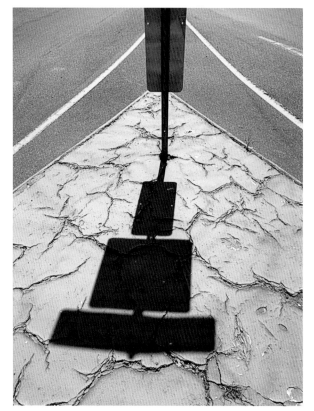

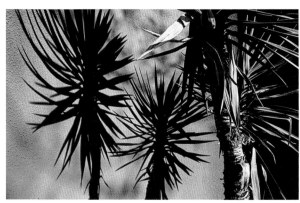

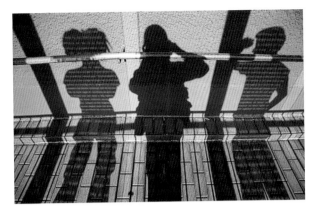

7	9		11
8	10		12

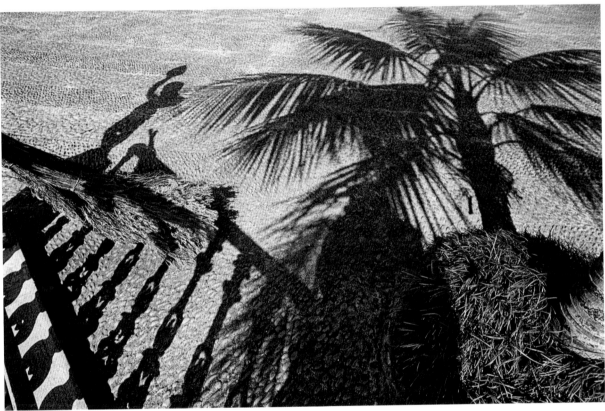

About the Photos

Shadows are best defined if they are photographed against plain, single-color backgrounds. Photos #4, 9, and 10 contain shadows that confirm our expectations, while the shadows in #2 and #3 show interesting deformations. Photos #5, 6, 7, and 12 contain obvious clues to the source of their shadows, while #1 includes a shadow that is purely abstract. Backlit subjects, like the one in #8, require positive exposure compensation. Photo #11 is an example of the photographer's own shadow becoming the subject of the photo.

15 Palm Trees

A Symbol of Warmth

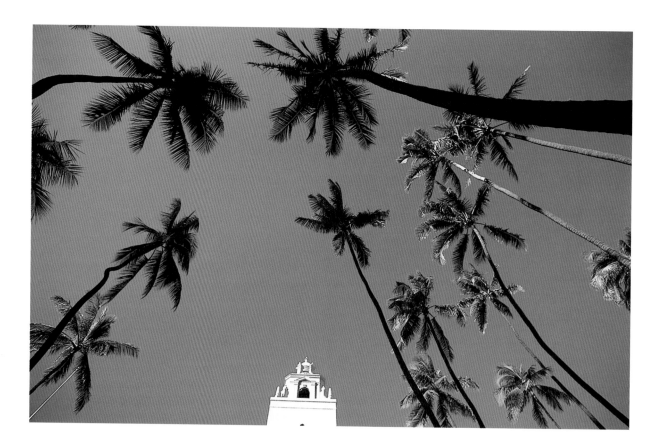

Trees and forests are themes that appeal not only to nature-lovers. Firs, beech trees, willows, poplars, and especially palm trees all have shapes that produce instantly recognizable shadows. Palm trees are also a distinctive symbol of warm climates and consequently symbolize vacations and holiday feelings. The stem of a palm tree is its dominant feature, usually dividing the frame either vertically or diagonally. The individual fronds grow in a star shape from the centre of the tree's crown, and their tips produce a pleasing circular shape.

The leaves of a palm tree form a point if photographed from a distance, and the viewer's mind will instinctively form lines and shapes within image if it contains multiple points. Lines, subsidiary lines, and division of lines are important aspects of composition in photos of palm trees. The central rib is the main visual component of palm fronds, and broad subsidiary lines that create their own shapes are formed on both sides of it by the leaves. Shadows (or shadow details) of palm trees also combine multiple lines to form their own shapes.

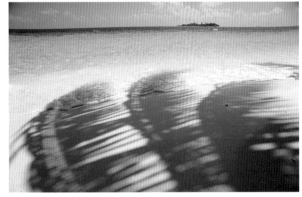

It is often difficult to quickly find the position and composition that most effectively portray a subject, and keen photographers seldom take just one picture of a motif. The final decision regarding which image really is the "best" in a sequence is made later. Digital technology has shortened these delays to a matter of seconds, although camera displays are seldom of high enough quality to allow proper decisions concerning image quality. Taking along a "digital darkroom" (i.e., a notebook computer) will help you to make informed decisions. If you shoot enough high-quality

images, you can always divide them into additional subthemes later.

In the case of analog photos, a significant period of time usually passes between shooting and image selection. For slides, a light table or projector may be used for later viewing. Contact sheets or small prints perform the same function for images made from negatives.

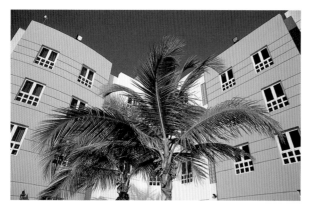

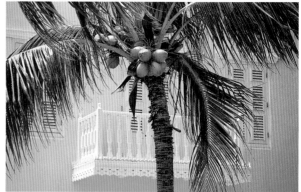

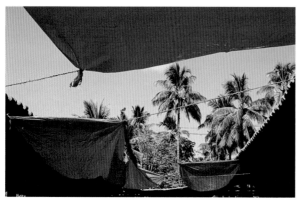

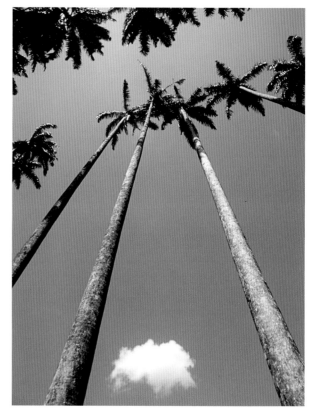

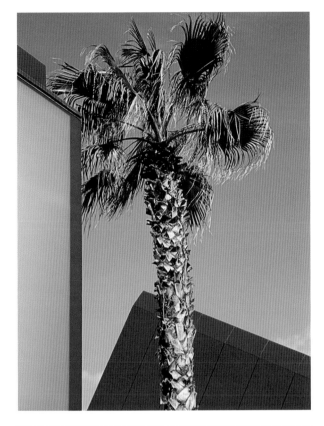

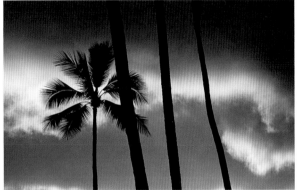

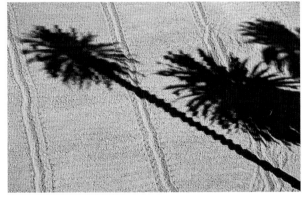

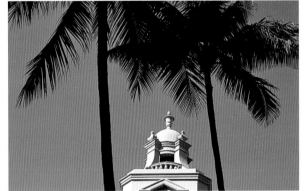

About the Photos

The silhouettes in #12 and #13 and the shadows in #5 and #11 all have formal charm, while photos #6, 7, 8, and 10 all include some of the subject's surroundings, creating truly colorful images. Photos #3 and #4 show indirect portrayals of palm trees in the form of reflections. Wide-angle shots, like #1 and #9, include a number of contrasting formal elements. Image #2 tells a simple story about tree maintenance at a holiday resort.

16 Cacti

Fascinating Plants with Built-in Defenses

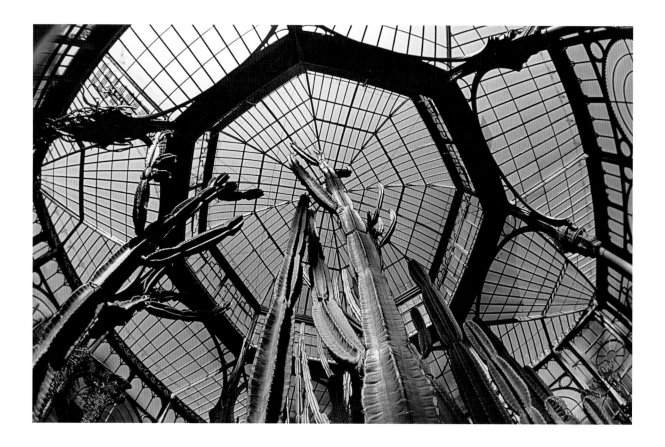

Nature is a multifaceted subject that often gives rise to excellent single images, but you will need a strong overall concept if you want to produce an effective photo series using a natural subject. Simple images of flowers and plants are only usually of documentary value and are not effective serial subjects. Large-scale views—for example, of Dutch tulip fields—or small-scale macro views are much better suited to serial use. Both of these approaches make familiar subjects more abstract and encourage the viewer to take a second look.

In order to take high-quality macro photos, you will need to use a special lens and a tripod. Backlit leaf veins that are photographed without betraying the overall shape of the leaf make particularly interesting photos. Close-ups of tree bark are also a great source of abstract shapes and colors. Cacti and other succulents can usually only be found in greenhouses or on windowsills in much of the world. Cacti originally come from North and South America and boast an estimated 3,000 species and 220 genera, making them, along with orchids, one of the most diverse families

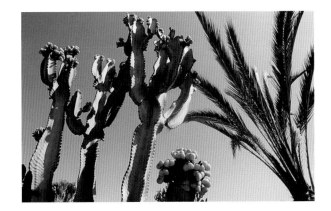

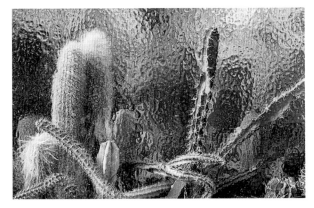

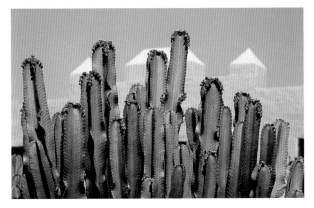

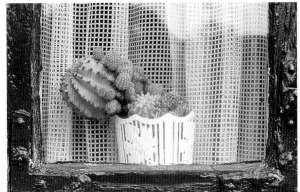

of plants on Earth. Cacti have been cultivated as indoor plants since the 17th century and have been mass-bred for about the last 100 years, making them affordable for everyone.

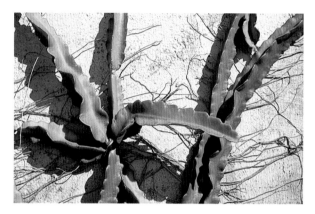

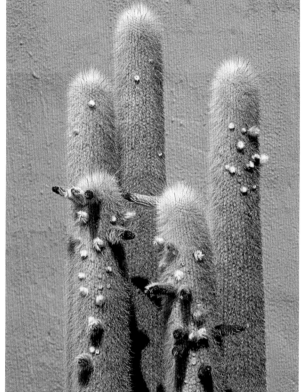

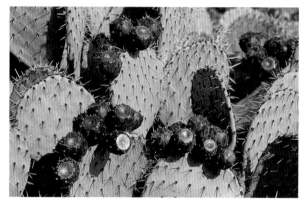

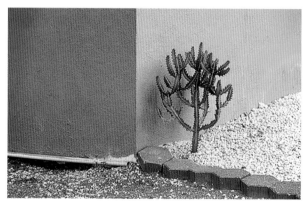

About the Photos

Greenhouses are a good place to see giant cacti like the ones in photo #1. Cacti that are kept behind glass in botanical gardens also make good subjects, as shown by photo #3. At appropriate room temperatures, cacti can even thrive behind glass in northern Europe (#6) or in central Europe (#12). In southern Europe (and especially on the Canary Islands), cacti are an integral part of most landscapes and gardens, illustrated by photos #2, 4, 5, 7, 11, and 14. It is only rarely that photos of cacti display colors other than green, but the shapes of the cacti themselves (#9) or other elements of the immediate surroundings (#10) sometimes prove that exceptions confirm the rule. Cactus blooms or fruit, as in #8, also provide a different take on the same theme. Some people even use cacti as living (de)fences (#13).

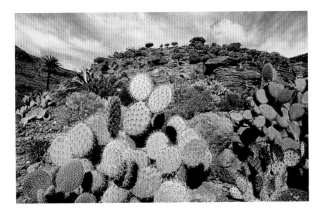

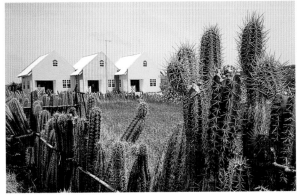

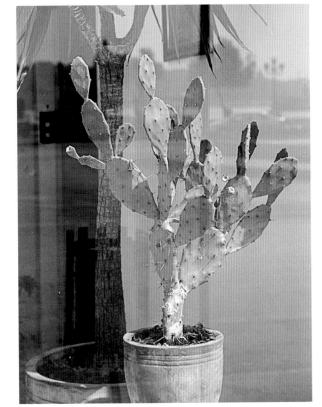

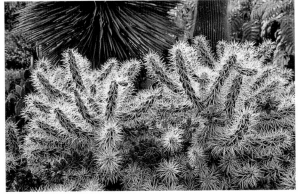

17 Views Through Buildings

Near and Far in a Single Image

Creators of visual media have always struggled with the problem of how to portray the three-dimensional world in two dimensions. Today, perspective is a widely understood phenomenon, but it took hundreds of years for artists to come to terms with the laws of perspective and to use them effectively in their work. Painters have to learn how to include perspective in their paintings, while a photographer's lens automatically captures the perspective of the scene it is aimed at. The precision of photographic reproduction is unforgiving, and photos will always betray the

careless use of a camera. Every slight tip or jog will be captured in the form of converging lines or distortion. If you intend to produce realistic-looking photos, you will need to take great care when you are using your camera, especially if you are shooting with a wide-angle lens.

In the field of subjective photography, there are no limits to how we can use technical and compositional tools to achieve our goals. Significant camera tipping while using wide-angle lenses emphasizes converging lines and increases the feeling of depth and space in the resulting image.

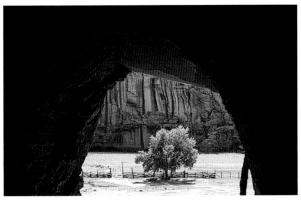

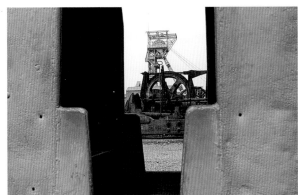

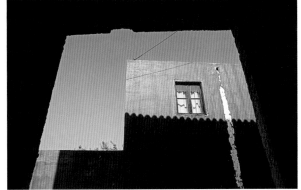

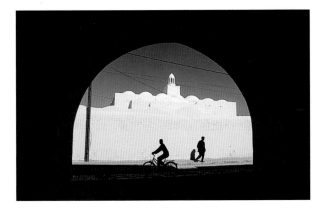

Alongside perspective, views past and through buildings are an effective tool for accentuating the spatial relations within a scene. This simple device divides an image into easily recognizable sections that are both nearby and distant, thus providing an additional sense of depth. Such views can be directed forward or upward. If they occur through openings from dark to light or on otherwise homogenous surfaces, they automatically direct the viewer's attention to the details in the background. If the foreground also contains interesting details, it will compete for attention with the background view.

Another way to emphasize near and far is to use the contrast between cool and warm colors. This contrast is more conceptual than rational. Active, warm red and orange tones positively attract the viewer and produce a feeling of closeness. If the background is a cool, blue/green color, the positive effect of the warm foreground will be increased. Monochrome black-and-white tones have simi-

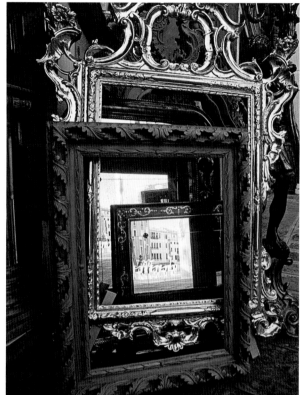

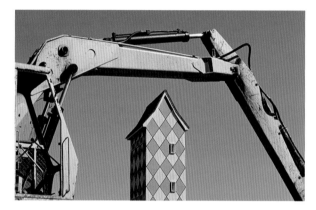

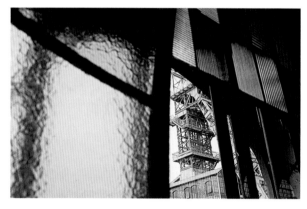

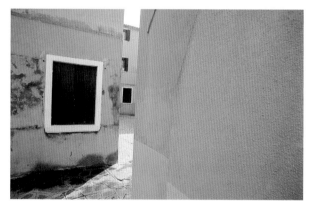

lar effects, with white belonging to the spectrum of cool colors and black producing a feeling of warmth.

You can change the apparent breadth or depth of a view through a building by changing your position, and you can often produce very different images of the same subject simply by using a different lens or rotating the camera from landscape to portrait format. The light at different times of day also plays a significant role in the overall look of an image.

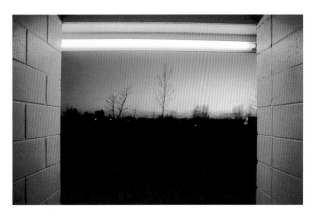

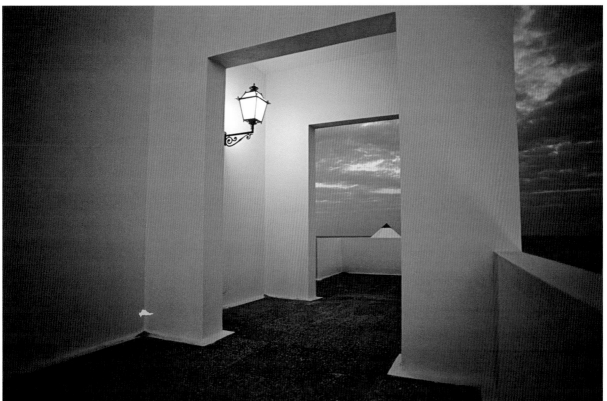

About the Photos

In photos #3, 4, and 6, dark foregrounds immediately emphasize the background detail. In photos #1, 2, and 5, strong foreground colors and bright image areas attract the viewer's attention before the eye perceives any background detail. Photos #7, 8, 9, 12, and 13 all contain strongly competing background and foreground elements. Wide-angle lenses help to emphasize foregrounds, while a careful choice of camera position (#10 and #11) makes it possible to photograph through the narrowest of gaps.

18 People Photographed from Behind

Trouble-free Portraits

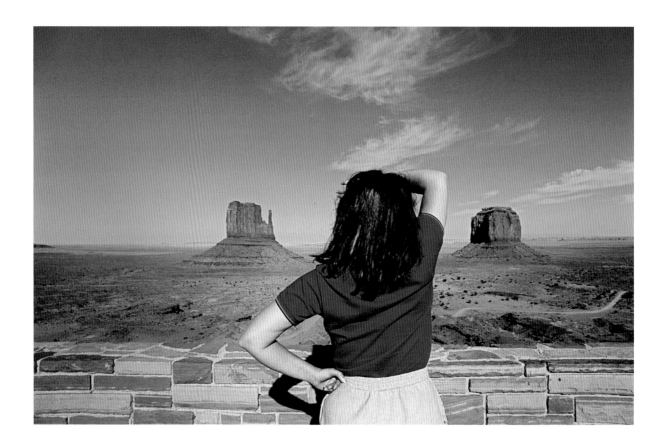

At one time or another, photojournalists who shoot for newspapers, magazines, or books have to make contact with people and take photos of them. While many people like to see pictures of themselves in print, it is nevertheless advisable to get your subject to sign a model release form before publishing. While professional photographers take pictures of people on a daily basis, even making eye contact with strangers is a significant emotional hurdle for most amateurs. Taking photos unobserved from a distance using a telephoto lens is one solution to this problem, but intro-

duces the issue of photographing people without their permission. Obvious eye contact between photographer and subject is often seen as the subject giving permission to shoot, whereas if you photograph a person unobserved, you are in danger of violating their personal rights.

But there is another way to include strangers in your photos. People of all ages are only individually recognizable if you can see their faces. Silhouettes and head-on shots or profiles photographed from behind make human subjects anonymous, while hair and clothing give us clues about a

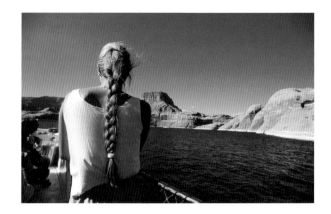

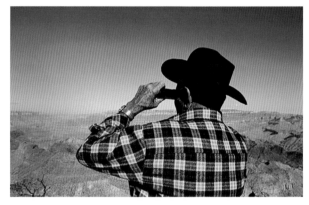

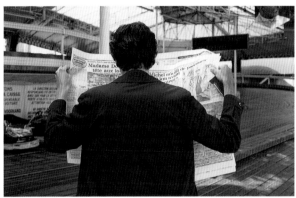

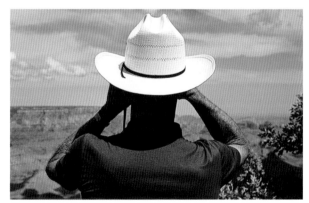

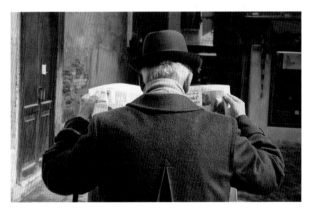

person's sex, age, and occupation. Photos of people looking into the distance introduce elements of scale and depth into an image, but positive and negative shapes are always the main compositional elements of "back portraits". The figure itself is obviously the main subject, emphasized by the bright/dark contrast between the subject and the background. This effect also automatically transforms the rest of the image into a negative shape. If you photograph your subject from close up using a wide-angle lens, you will usu-

ally be able to capture sharp background detail. If you use a longer lens, the background will remain blurred.

You can take pictures of people who are moving from behind too, although movement makes it more difficult to position your subject accurately within the frame. If you are shooting with a fixed focal length lens, you will have to move at the same speed as your subject to get your shot. If you are using a zoom lens, you might not have to move yourself, but you will nevertheless have to decide quickly which is the best moment to release the shutter. You can

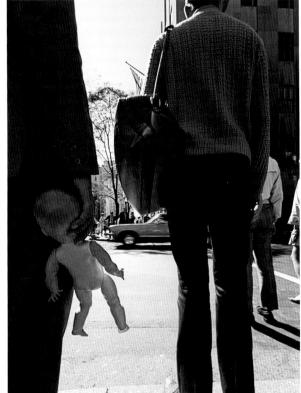

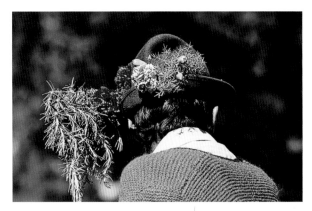

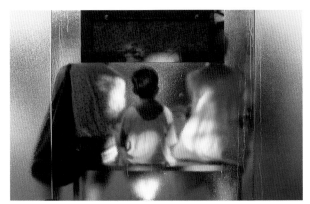

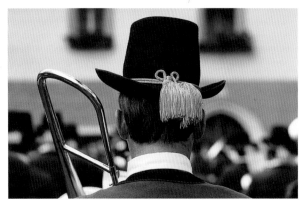

only really work at your own speed if you are photograph-ing people who are waiting, reading, or who are themselves observing other events. Colors will play a greater role in images in which your subject is frontally lit, while backlit subjects are often silhouetted against the background. If you take pictures of people through textured glass, their appearance is not just anonymous, but also abstract.

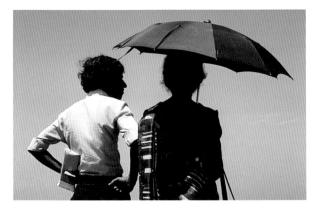

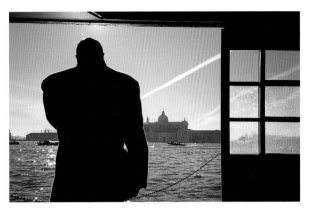

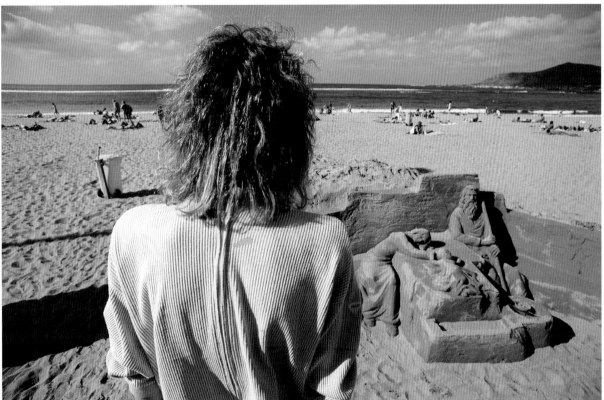

About the Photos

People often stand still for long periods of time on ships (#2) or at viewpoints (#1, 3 and 4) while they observe their surroundings or just gaze into the distance. Festivals also provide great opportunities for back portraits, as shown in #7 and #8. Interesting newspaper articles or other surprises often cause people to stop in their tracks, as in photos #5, 6, and 13. The silhouettes in #11 and #12 are in stark contrast to the sky, while the textured glass in #10 blurs the contours in the image almost entirely. Photo #9 is an example of the curious situations that you can often capture at pedestrian crossings.

19 Dolls and Mannequins

People-shaped Toys and Ornaments

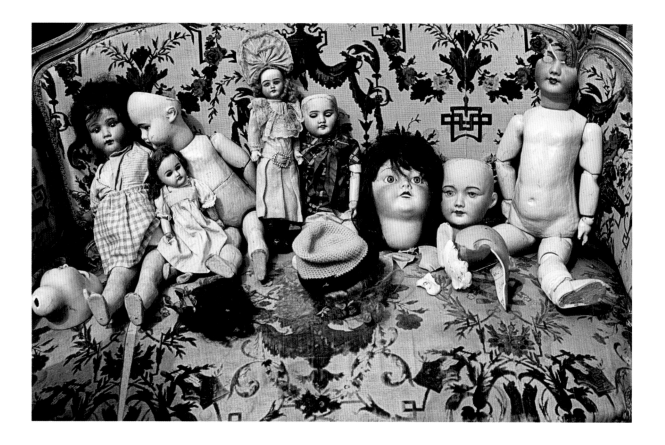

The earliest paintings and sculptures made by humans were of the animals they hunted. Since the first handprints and abstract stick figures were made, every civilized society has produced its own two- and three-dimensional representations of the human body, fertility symbols, and gods. For hundreds of years, creating images of people was the preserve of artists commissioned either by the rulers of the time or the church. It is only recently that society has developed sufficiently to allow every free-thinking artist to cre-

ate the broad range of figurative images that we now take for granted.

Accurate representations of the human figure can be found in wax museums or the windows of countless stores all over the world. The mannequin theme provides opportunities to photograph interesting details and also has a surreal aspect all its own. Reflections in store windows allow you to seamlessly combine indoor and outdoor scenes. Twenty or thirty years ago, displaying "naked" store mannequins was punishable by law—nowadays, nobody gives an

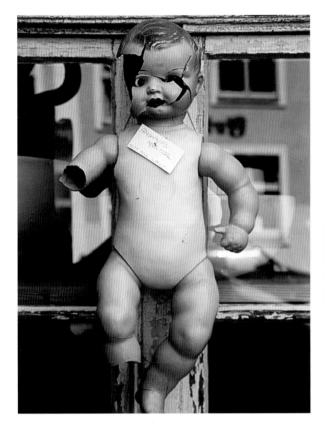

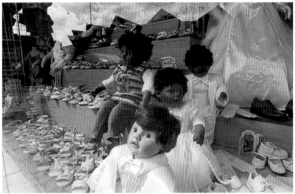

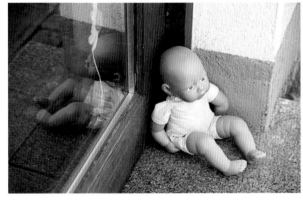

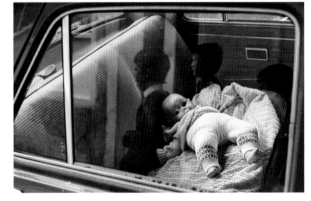

unclothed mannequin a second glance. Most figurative works, and especially sculptures, are created to last "forever" and are made of durable materials such as marble, bronze, and, more recently, plastic. The ice and sand sculpture competitions that have gained popularity in recent years deliberately introduce an element of transience, making photographs the ideal form of documentation for this type of subject.

Dolls have also continually evolved over the years in their dual roles as collectables or toys. Dolls and doll parts can often be bought cheaply at flea markets, but can also fetch significant sums at auction. Daylight shots of dolls do not present any problems relating to color temperature, but mannequins are often located under mixed light sources during the day and are illuminated by artificial light at night. Warm artificial light lacks a blue component, leading to strong yellow/orange color casts if you shoot on daylight film at night without a blue filter. Digital cameras usually have both an automatic white balance feature and a manual color temperature setting option.

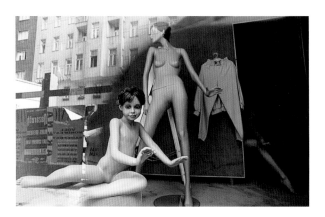

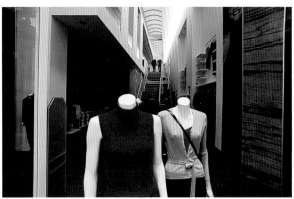

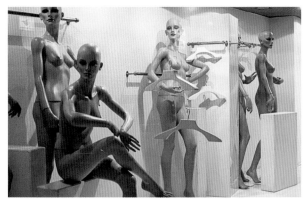

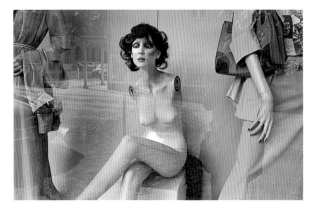

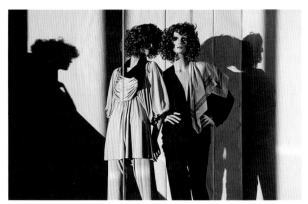

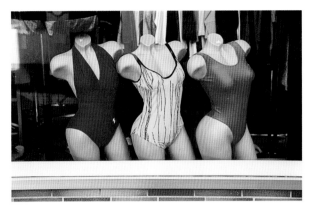

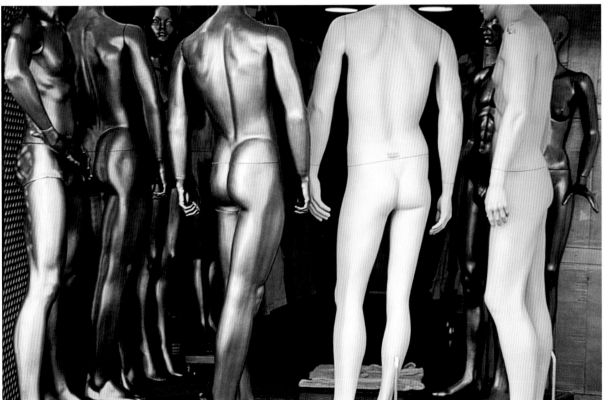

About the Photos

Dolls are often displayed decoratively at markets and in antiques stores, as shown in #1 and #2. Baby dolls are often well-loved, but just as often abandoned, as shown by #3 and #5. Photo #4 shows a shoe shop in which children's shoes are modelled by life-sized dolls.

Variations on headless, armless, and even legless mannequins are shown in photos #6, 7, 10, and 12. The warm tones in #11 were produced by the evening sun, while the yellow cast in #9 was produced by the artificial light used to illuminate the store window. Photos #7, 8, 9, and 13 are proof that unclothed mannequins no longer cause trouble for store owners.

20 Shoes and Gloves

Between Luxury and Necessity

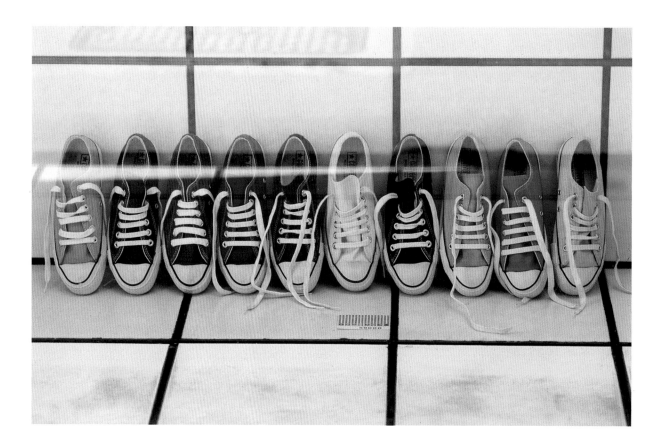

Life without shoes is inconceivable for most people. On a beach or at a swimming pool are two of the rare occasions when we willingly go without footwear. Originally conceived to protect our feet, shoes have developed over the centuries into designer objects of desire and specialized items of clothing that cater to every imaginable use. A lot of effort is made to display and sell shoes, making them a perfect subject for a photo series. Shoes are photographed singly and in close-up for catalogs, but here, we are more interested in capturing realistic, everyday views of shoes on display.

Shoes also present a photographer with interesting elements of shape and color design. Shoes generally fall into the compositional category of "points within a shape," just like all other objects that are themselves small but which are photographed against large backgrounds. Shoes often appear in pairs, transforming a single point into a multi-point image element. In store window displays, these

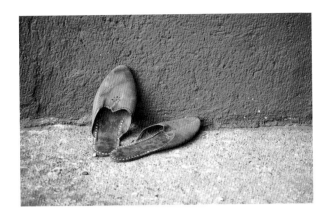

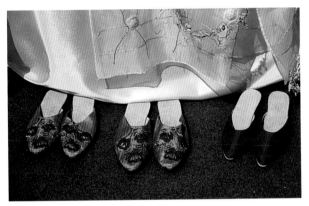

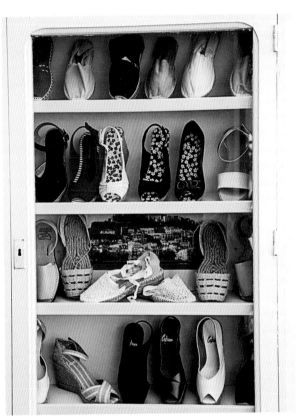

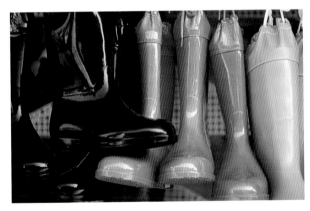

multiple points form the basic elements of a pattern that can fill the entire frame.

The same is true for displays of gloves. Gloves and shoes are only complete if they appear in pairs. Single lost shoes are relatively rare, while single lost gloves can be found often enough to justify a photo series of their own. Gloves can be hung out to dry, set aside at work, or worn as part of a costume or uniform—but always in the form of an identical pair. Massed displays of gloves are rare outside of store windows or in-store displays.

Gloves and shoes are themes that you can photograph at home and abroad, and observant photographers are sure to find related subthemes, such as gloves and shoes used for advertising or other, similar purposes.

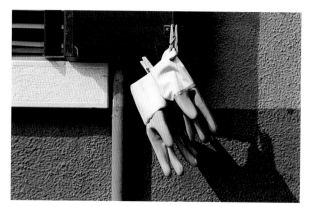

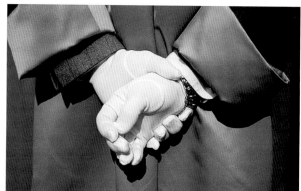

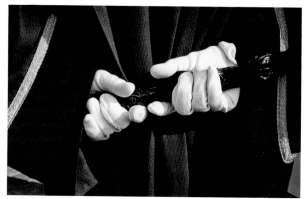

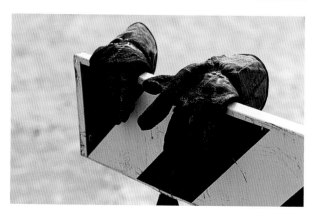

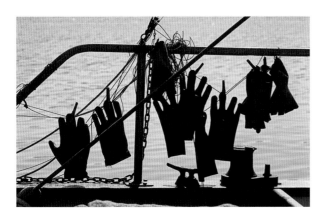

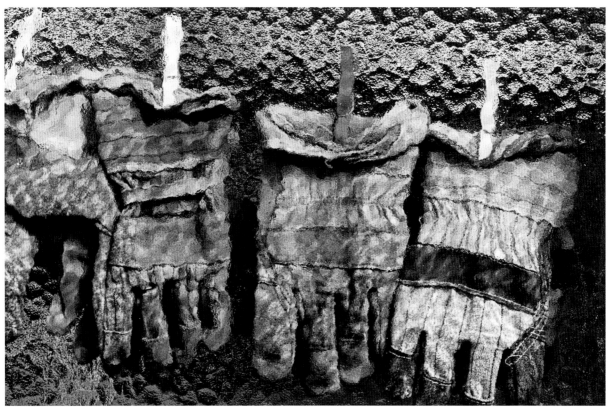

About the Photos

Singe pairs of shoes or gloves photographed against a large background automatically become the dominant point within the frame, as shown in photos #2, 6, 7, and 8. Points that lie close together produce imaginary lines, even if the shapes and colors of the objects are not identical. In photo #1, a single shoe in various colors forms such a line, while in #3, the similar colors of the two different models are the common factor. In photo #4, the yellow and orange boots reflect only highlights, while the black boots reflect the blue of the sky and the colors of other nearby objects. Photo #5 shows how closely-packed shoes can form an overall pattern independent of the look of the individual shoes. The gloves and the backgrounds in #9 and #10 compete for the viewer's attention, while #11 and #12 show gloves that form subsidiary, overriding patterns.

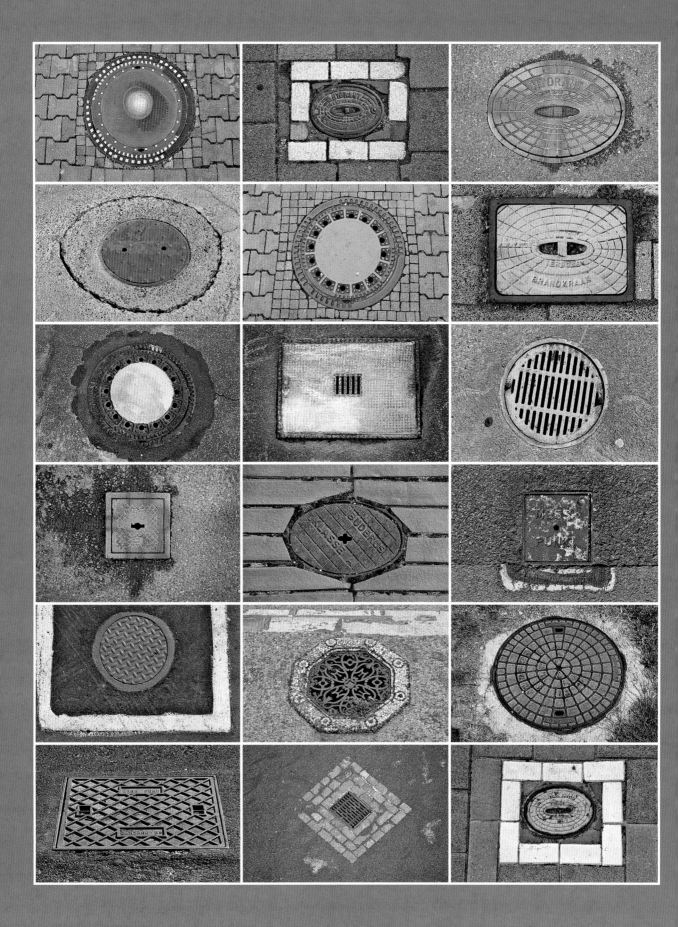

Part 2

Serial Photography and Design Theory

Every finished photo adheres to the simple rule: No image can have meaningful content if it isn't carefully composed. Considered use of point, line, and shape are necessary if you want to portray a subject successfully. You can apply these design elements as minimalistically as you like, and a single point on a surface or a single horizontal line stretching from edge to edge of the frame is often sufficient to give an image substance. Artistically applied contrast can make images with virtually no content nevertheless appear visually interesting.

Formal elements of an image can also play a significant optical role, and can even form part of a picture's message. Repeat patterns are the main defining formal element, making a photo series the ideal format for this type of experiment. For example, a single point placed in the center of the frame can form the basis of a photo series, independent of what the point actually portrays. Our "Doubling Up" and "Triples" themes offer potential for expressing visual humor, and are based on the simple repetition of two or three main points or the presence of two or three objects. The actual subjects vary widely, helping to keep the work interesting for the viewer.

This multisubject approach also encourages the viewer to look for differences or commonalities among the subjects. Every viewer automatically becomes the judge of an image, although an objective judgement is impossible. A viewer will react to and subjectively judge an image according to accumulated knowledge and a specific level of interest. In order to judge the quality of an image's composition, you will need thorough knowledge of design theory and how it can be applied to create balance in an image.

Every image creation technique, whether drawing, painting, or digital or analog photography, requires a certain level of knowledge and technical skill if it is to be carried out successfully. Critical appreciation of an image requires the critic to have foreknowledge of the techniques involved in its creation. As previously mentioned, a successful photo series doesn't have to consist exclusively of perfect images, but it shouldn't contain basic errors such as unintentionally cropped objects or distracting blemishes.

21 Doubling Up

Born of Nature and Necessity—Often Witty and Inventive

If a design element is to function as a "point," it needs to contrast with its surroundings. A small light, dark, or colored object contrasts either with the size, color, or brightness of the background it is portrayed against. A formal point element doesn't have to be round or have a smooth edge—a point is any small object that is clearly separated from its surroundings. Small shapes thus take on point characteristics, even if they are considered by the viewer to be ordinary, everyday objects.

Although it represents stillness and calm, a single point can nevertheless dominate a much larger surface. Two similar sized (or colored) points introduce discord into a composition. The viewer's eye swings between the two points and feels compelled to decide which is more important. Two points are always joined by a straight line, as we always choose the optically shortest distance when we create imaginary connections. The main characteristics or implicit humor of a double subject usually only become obvious when it is photographed to fill the frame. Some subjects,

such as gloves, shoes, eyeglasses, arms, legs, or eyes come naturally in pairs, but subjects that are accidentally conjoined surprise and amuse us. Identical shapes and colors, or identical objects with differing colors, encourage us to take a closer look. Collections of images that deal with multiple subjects are often colorful and pleasingly mixed, while collections that concentrate on a single motif, such as bridal couples, twins, feet, or double doors, tend to take on a more documentary character.

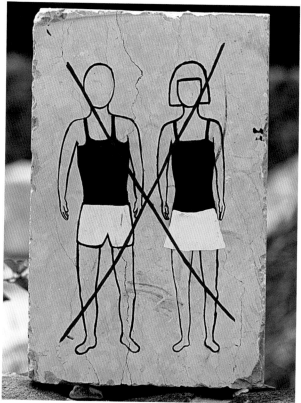

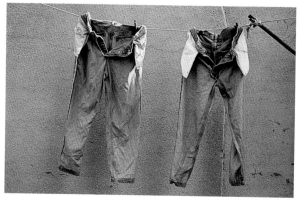

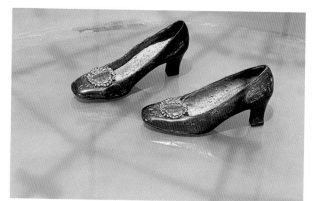

About the Photos

Objects that are photographed to appear small in relation to the background are nevertheless usually seen as the subject of the image and not as a point on a surface, as demonstrated by the two sunshades in photo #1 or the two padlocks in photo #11. Photos #3 and #6 show obvious color differences between otherwise identical objects, whereas the identical form and color of the two paint buckets in #12 fuse them into a single visual unit. Finer differences are provided by the paint brush and the mixing stick, or the handle

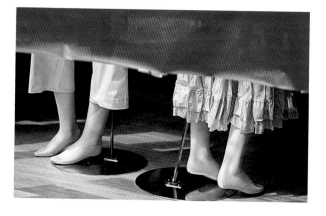

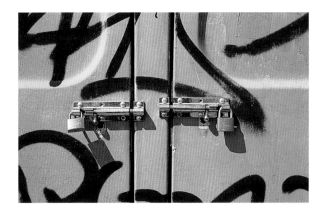

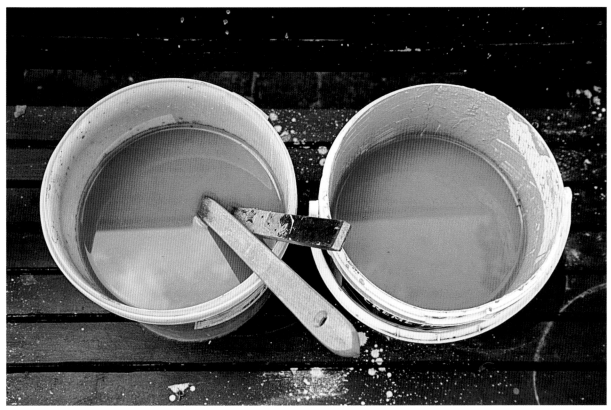

on the right-hand bucket. Photos #2, 4, and 5 are examples of twin subjects that are rotated and mirrored. Some double subjects have their own individual double characteristics, such as the two tires in #1, the legs of each pair of jeans in #7, or the legs of the store window mannequins in #10. Two identical red lines drawn through the figures in #8 draw attention to the local dress code. The shoes in #9 are a genuine pair, photographed at a fairy-tale theme park. Choosing the right size for pairs of points on a surface is a matter of experience, and it is often a good idea to shoot a number of different versions of a scene and to select your best shot later.

22 Triples

The Same, but Different

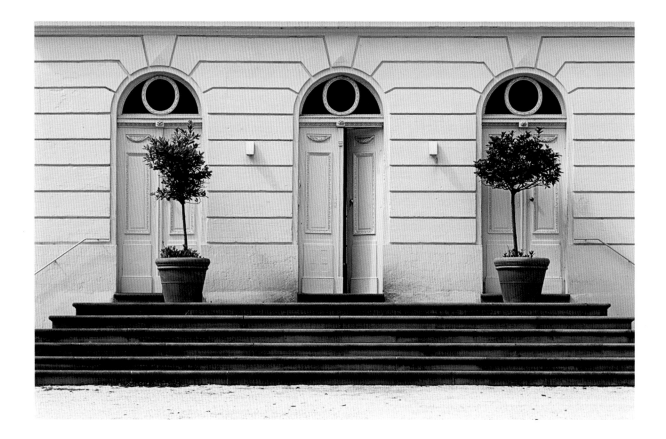

People have always been fascinated by special numbers and multiple objects: absolute uniqueness, twins, triplets, or the magic of a perfect square are just some examples. Without objects to relate them to, numbers can be emotionally perceived as lucky or unlucky, but at the same time can just as easily serve the rational logic of mathematics.

Three points within an image can have different visual effects, depending on how they are arranged. They can form imaginary vertical, horizontal, or diagonal lines, but if one of the three points is positioned away from the line,

they immediately form a triangle whose connecting lines are also imaginary.

A triangle is the most active of the basic geometric forms and indicates movement in three directions at once. The effect of an imaginary or a real triangle is stronger if one of its sides lies parallel to the edge of the image frame. Whether three similar objects actually belong together depends on either necessity or chance. The three legs of a tripod, a stool, or a concert piano are born of necessity, and ensure that the object in question remains stable, although

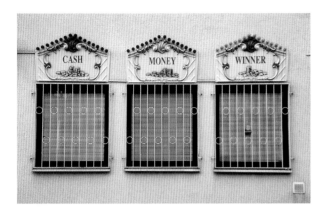

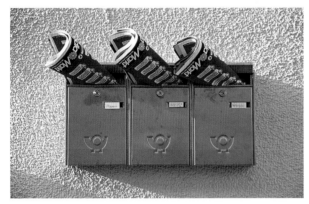

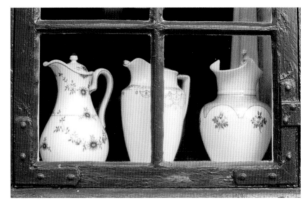

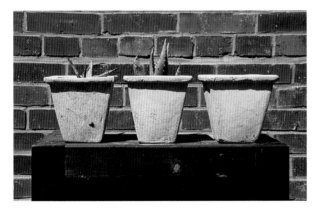

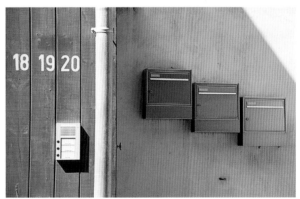

three points don't guarantee that the object will remain parallel to the ground.

Some objects, such as tricycles, triangles, or tridents already include the Latin prefix "tri-" (meaning "three") in their names. A cloverleaf is the best-known triple object in nature, but it also proves that the number three is not absolute. Just as clover can have four or even five leaves, an observer can also imagine other triple objects in larger or smaller numbers. Three objects arranged on a surface are immediately recognizable as such without having to count

them, irrespective of whether they are the same color or the same size.

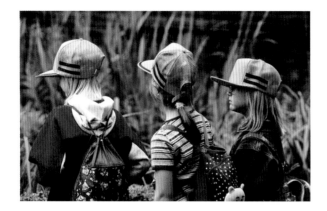

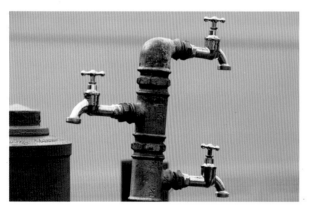

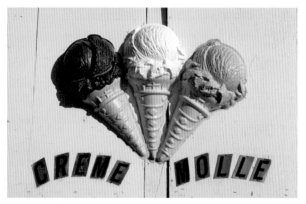

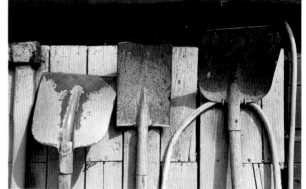

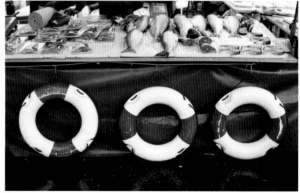

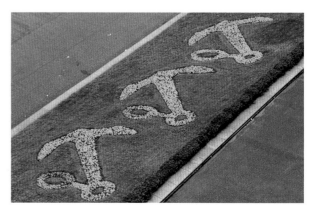

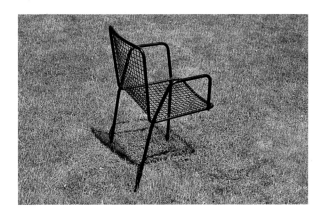

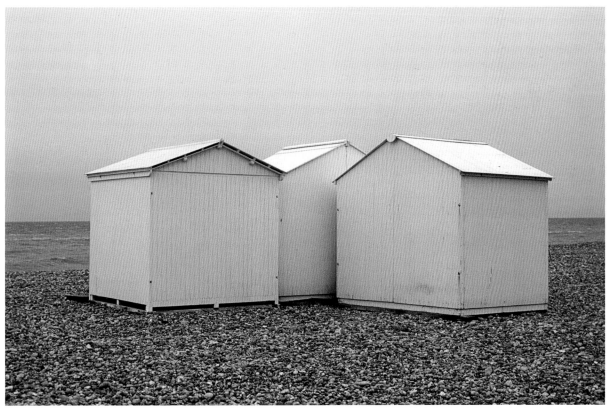

About the Photos

Images that make a clear statement don't need captions. Once you have seen that they contain three similar objects, you can inspect their subtleties and differences at leisure. Photos #3, 4, 11, and 12 are the ones that contain the smallest differences between the objects, although the left-hand lifesaver strikes the viewer immediately because it is rotated. Photos #2, 7, and 8 contain differences in color or labeling, while #5, 9, 10, and 14 show obvious differences in the basic shapes of the objects. Photo #1 unites double and triple motifs, with its two handrails, two lamps, two plant pots, and three doors, while photo #6 takes the prize with its three sets of three objects. Photo #13 shows a more surreal, humorous approach to the theme.

23 Semicircles and Circles

Calm and Harmonious

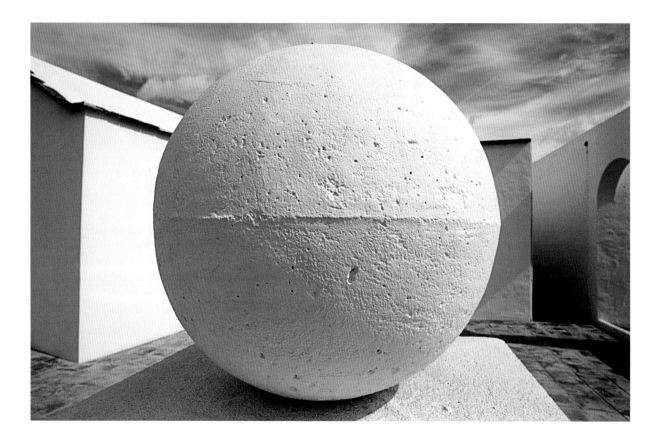

Along with squares and triangles, circles form the basic "shape" elements of design. These shapes, along with other geometric shapes such as ovals, rectangles, and trapezia, form the basis of the sheer endless number of shapes a photographer can use in a composition. Ideally, image content will be emphasized by the elements of design an image contains. The contrast between different shapes can be accentuated by differences between dark and light and also between contrasting colors. Contrast can also exist between different freeform and/or geometric shapes. Cir-

cles that form part of a rectangular composition cause problems due to the empty spaces (or "negative forms") surrounding them. The most pleasing way to compose a conventional image containing a circle is to place it within a square. A circle placed within a 2:3 rectangle (the same format as a 35mm film frame) leaves a third of the surrounding surface area "empty". If you compose such an image in landscape format, it helps to place the circle in the center of the frame. The remaining "negative" space is then distributed evenly to the left and to the right of the main subject,

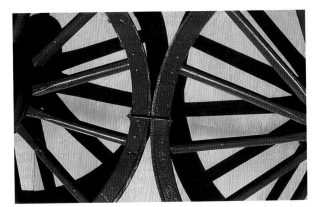

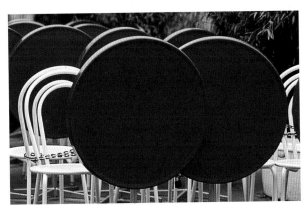

and avoids producing an unbalanced overall look. If you are shooting a circular subject in portrait format, shifting the circle slightly upward helps to keep the overall composition looking balanced. A circle that is positioned near the lower edge of the frame tends to look as if it is sinking toward the bottom of the image.

A circle has an intrinsically balanced shape that an observer automatically sees in its entirety, even if it is not completely visible within the frame. A circle that fills the entire width of a rectangular frame has to be cropped along

at least one side, although experience and the remaining arc help the viewer to complete the imaginary circle anyway. If you want to include two or more circles in a single frame, it is virtually impossible to avoid overlapping them. These implied "in front" and "behind" aspects produce an additional feeling of depth in two-dimensional images.

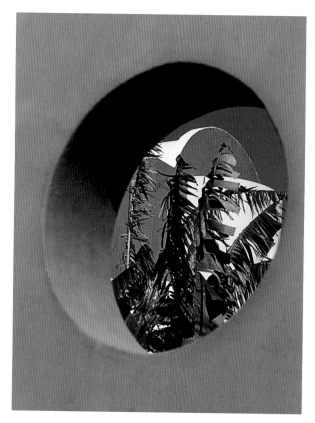

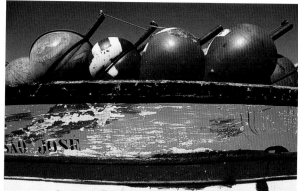

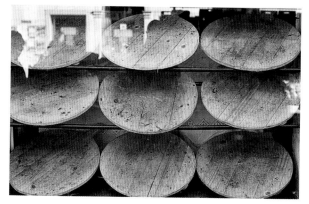

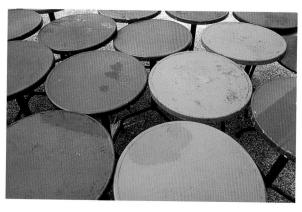

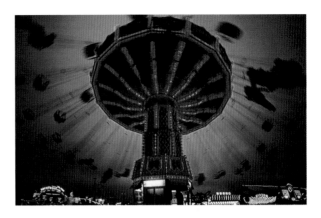

About the Photos

A sphere is a three-dimensional circle. Spherical objects such as balls, balloons, or melons are easy to recognize, whereas help in the form of light and shadow is required to help us recognize abstract subjects like the one in photo #1. Overlaps and crops are unavoidable in images that contain multiple circles or spheres, like photos #6, 8, 9, 10, and 11. Photos #3 and #12 show single, centrally-placed circles, while the circle in #7 is positioned toward the top of the frame. Although they are heavily cropped, the wheels in #4 are instantly recognizable. The horizontal circle in image #12 was photographed at a slant, creating an oval impression. Photos #2 and #5 show that real semicircles do exist along-side those that are made using creative cropping.

24 Lines and Stripes

Dynamic Movements Within the Frame

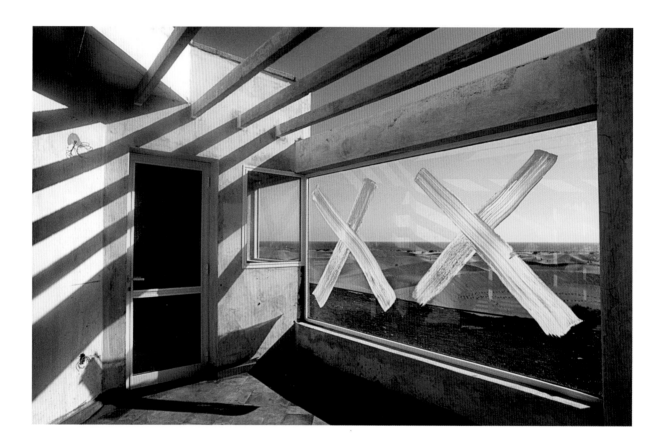

A point that moves forms a line, creating movement in an otherwise static object. Painters and illustrators move pencils and brushes to create lines. You can use your camera to document existing lines, or you can create lines photographically by using long shutter speeds and camera movement to bring static points to life. A long shutter speed with a fixed camera can capture the lines produced by moving points. Both of these techniques embody a slightly random approach to image composition, and you can only keep complete control of your composition if you document existing subjects. Lines only make sense as a serial theme if they are multiple. Multiple lines then form the artistic design elements "lines," "accompanying lines," and "linear contrast." The movements created by lines within a frame can be vertical, horizontal, or diagonal.

Stripes lie somewhere between shapes and lines in their compositional significance. A stripe is broader than a line but nevertheless has length that precludes it being seen as a surface with an implicit shape. Stripes, too, are most effective when compounded. Two parallel lines or

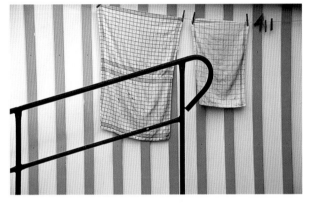

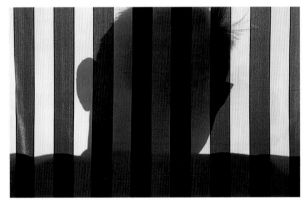

stripes represent the contrast between two colors. This contrast between light and dark is most effective when it fills the greatest possible space within the frame, producing a constant rhythm and a calm overall feel. Contrast between multiple colors causes the viewer to search for similar colors and distracts the eye from the rhythm of the stripes. Checkerboard patterns created by multiple shadows make very interesting photos that are characterized by the slowly changing interplay between light and dark lines.

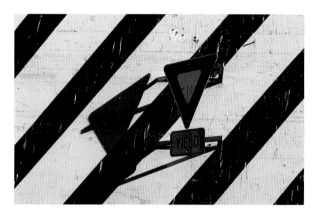

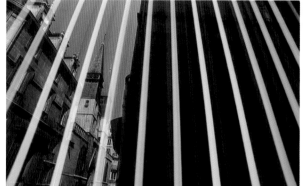

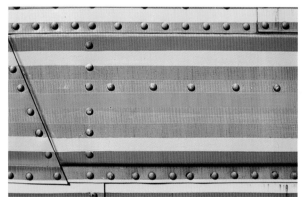

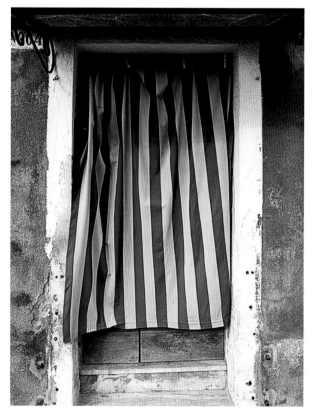

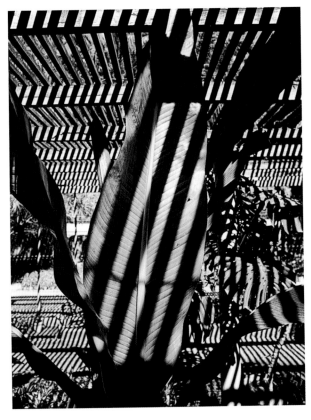

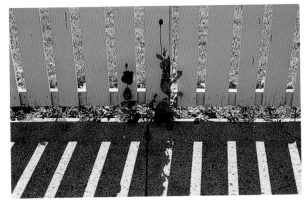

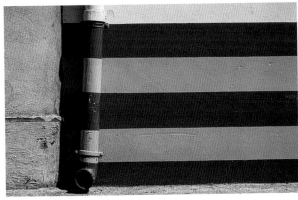

About the Photos

Photos #3, 6, 7, and 10 show measured interplay between single colors and black or white, while #12 and #14 show contrast between two different colors. The multiple colors in photos #4, 5, and 8 immediately attract the viewer's attention, although the broad stripes on the garage door don't adhere to a recognizable pattern. Photos #5 and #8 contain colors that are mirrored from the horizontal and vertical center lines. In #8, the real and imaginary optical lines are underscored by the lines formed by rivets. The gaps between the neon tubes in #9 appear as physical stripes. While horizontal and vertical lines produce calm, balanced images, photos #1, 2, and 11 are examples of the heightened tension produced by diagonal and slanted lines. In these images, the active diagonals produce a dynamic that exceeds that of the subject itself. The light and shade effects in #13 are much stronger than the effect of the fence, which is the intended subject of the image.

25 Checkered Patterns

Large, Small, Static, and Dynamic Squares

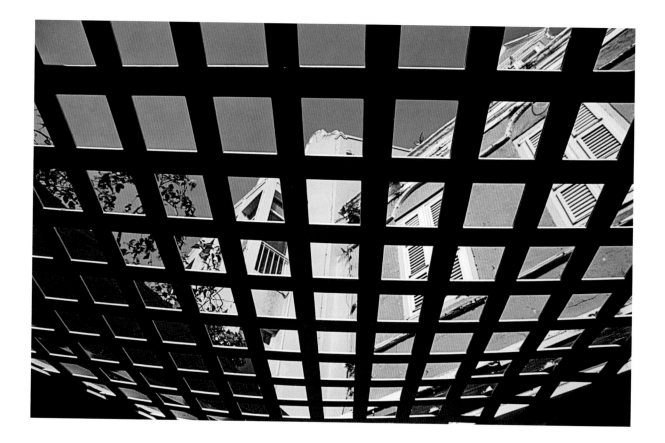

Regardless of the medium used to record it, an image is always first perceived on a rational level according to its content. This initial reaction is followed by an emotional reaction to the recognized subject, and then by analysis of the formal and artistic qualities of the image itself. Design theory and color theory intersect at various points.

The basic triangle, square and circle shapes are perceived not only according to their color, but also according to certain characteristics. The imaginary movements produced by triangles make them the most active of the three

and cause them to be associated with shades of yellow. The omnidirectionally calm shape of a circle is considered to be "blue," the color of the far distance. Squares are often considered to be the immovable, level foundation on which all other forms are built. This "inner peace" is associated with strong, pure red. A square design element can be more universally used than a triangle or a circle, which are seldom used as a basic image format. Square (i.e., 1:1) images have an innate calm, but lack tension, creating other types of compositional problems. Taken to extremes, a rectangle's

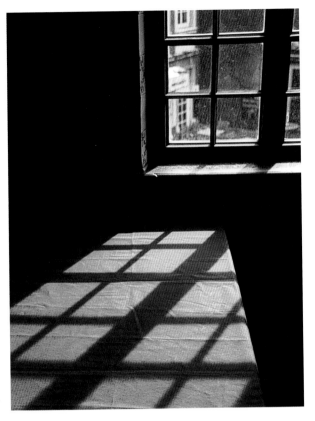

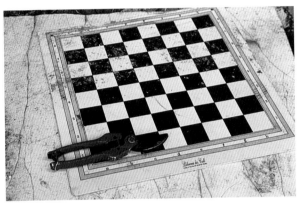

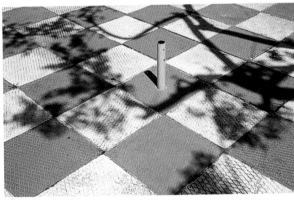

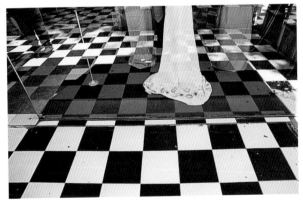

own inner tension, caused by the unequal lengths of its sides, can actually distract a viewer from other inadequacies in an image. In contrast, a square image unforgivingly emphasizes every little error it contains. A square balanced on one corner can surprise the viewer—a 45-degree rotation turns a calm, static square into a dynamic, active shape with implied movement in all directions. This characteristic underscores the fact that a square can be divided into as many as four triangles using simple straight lines.

About the Photos

Rows or blocks of squares can have static or dynamic effects, depending on how they are arranged and how they are viewed. Even static squares take on a trapezoidal form if viewed at a slant. Photos #6 and #7 show multiple squares arranged statically. Photo #2 displays a mixture of static checks and shadow-based dynamism. The classic checkerboard look in #4 and #5 allows us to overlook the slight distortion in the individual squares. Large areas are often divided up into smaller squares by the wood or metal bars in windows and roofs.

When a large number of small squares are arranged next to each other, the result is a check or harlequin pattern that can, in turn, be distorted by the camera angle (as demonstrated by #1 and #10). The steps in #9 are made from contrasting squares and rectangles. The dynamic effect of a square tipped onto its corner is shown in #3 and its use in classical architecture in #8. The goal net in #11 is accurately knotted but less precisely hung.

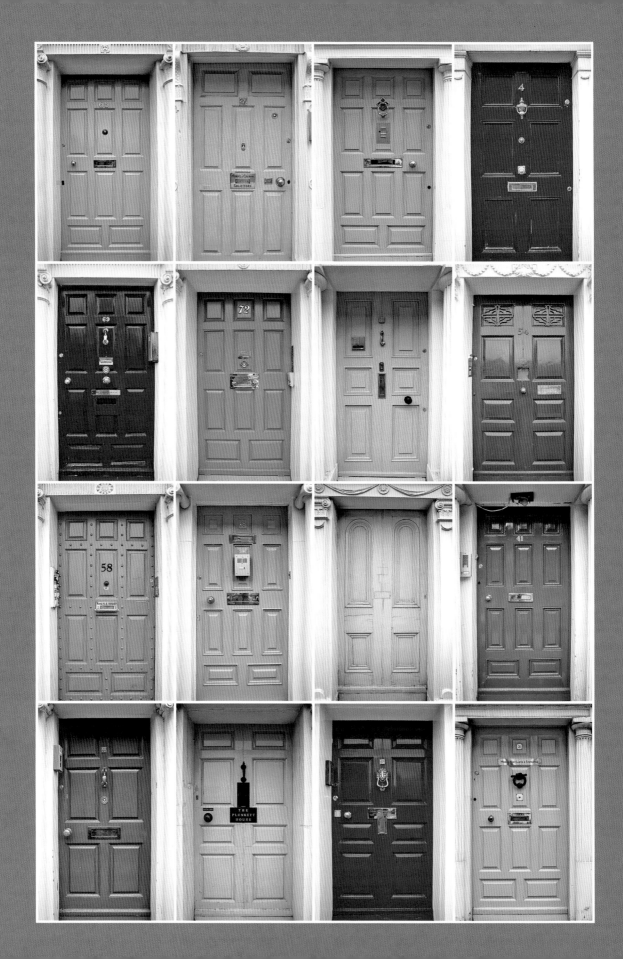

Part 3

Serial Photography and Color Theory

Images need to have a common factor—or "bracket"—if they are to work as a series. With a little forethought and careful preparation, a series can be united by multiple brackets. For example, if you select images with different subthemes that have the color red as their common theme, "red" remains the only common factor. If, however, you concentrate on shooting details of red cars, you have two nested brackets, namely: "red" and "cars." If you then further refine your subject selection to include only red cars photographed in the rain, your brackets become even more nested.

All pure primary and secondary colors are suitable themes for a photo series, although, for instance, it can be quite difficult to find a sufficient number of purely violet subjects. But color theory offers other approaches to formulating a series. Contrast between colors can be loud and direct or subtle and muted. The more quickly the theme can be recognized, the more effective a photo series will be, making bright colors the obvious choice. Three different, bright colors provide the highest levels of contrast, and the three primary colors—red, yellow, and blue—are the loudest and most cheerful. Contrast increases with the introduction of every new color until the choice of pure colors is exhausted and we are faced with another familiar subject: the visible spectrum.

Color theory also deals with the contrast between light and dark, which is particularly effective when monochromatic black or white tones are combined with brighter colors. Complementary colors—i.e., colors that lie at opposite sides of the spectral color circle—also produce high levels of contrast that are suitable for use in serial photos. Red/green is a familiar complementary pair, while other, less common pairs, such as yellow/violet, are more difficult to find. Cold/warm contrasts are generally too complex to make a theme of their own, but are nevertheless present when two contrasting colors appear in a composition. The overall effect of any image is a result of the sum of the contrasts present in it, whereby muted contrasts are always of secondary importance to strident, primary contrasts.

26 The Color Blue

(Nearly) Everyone's Favorite Color

In addition to their traditional divisions into active and passive, warm and cold, or light and dark tones, colors can also be used to create moods. People like different colors for different reasons, but surveys have shown that most people prefer blue to red. Looking at the sky is therefore, theoretically, a calming thing to do. In practice, we rarely look straight up at the sky, and we usually register the sky together with nature's green tones. The contrast between green and blue is one of the most common we know, in spite of the fact that blue (a primary color) and green (a sec-

ondary color) lie very close to each other in the color circle. Juxtaposed blue and green tones muddy each other, and blue tones can have a green cast just as easily as green tones can have a blue cast.

Pure green and pure blue are positioned next to cyan in the 12-sector color circle and thus belong to the cool colors of the spectrum. Cyan is also known as "ice blue", which is the coolest of the pure colors. Cooler colors are unobtrusive and are often used to symbolize distance. Generally, brightly lit colors are perceived as cool, while shaded or subdued

colors are perceived as warm. If you are familiar with color theory and your own sensitivity to colors, you will find that you even react to cold/warm nuances that exist between different tones of a single color. If small amounts of warm colors are present in an image that is composed mainly using cooler tones, the contrast between the sizes of the different colored areas will play a role in the overall feel of the image.

You can use cold/warm contrasts to great effect in a photo series or a slide show. Following a sequence of cool images with an emphatically warm image has a very pleasing effect on the viewer. The converse, i.e., following warm images with cooler ones, is just as effective. Exhibitions and magazine layouts often deliberately use color contrasts to influence the viewer's feelings.

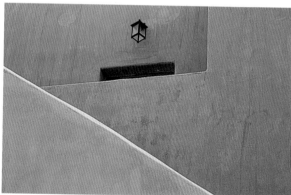

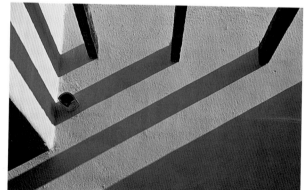

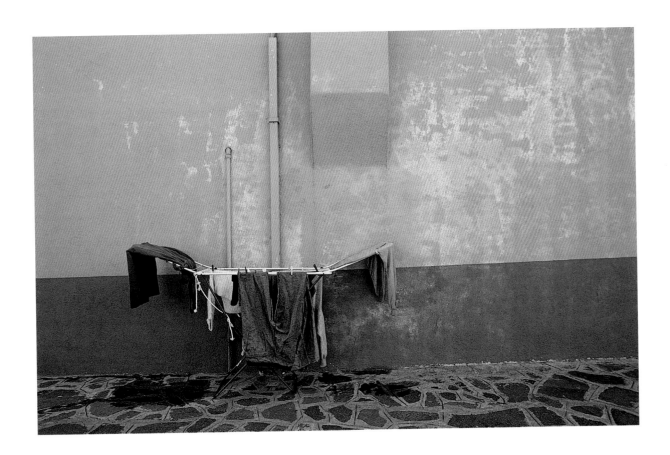

About the Photos

If an image is to be part of a "blue" series, other colors should only appear in small amounts. Photos #1, 2, 4, and 11 include small elements of color and shape that nevertheless play a significant role in the overall composition. Photos #3 and #10 contain extremely small colored counterpoints distributed over the entire image. The lines in #5 and #9 form shapes that compete for attention with the blue that is the actual subject.

If possible, always photograph your subject at various times of day. Early morning sun and evening sun, with low Kelvin values, give images a warmer look if they are shot using daylight film or daylight color temperature settings. Photos #4, 5, 6, 7, 8, and 9 were all shot at a holiday resort where the buildings were all painted the same color. The differences in basic image tone are due to the changes in light that took place during the course of the day.

27 Colors and Non-Colors

Active Red—Paired with the Opposing Poles of Black and White

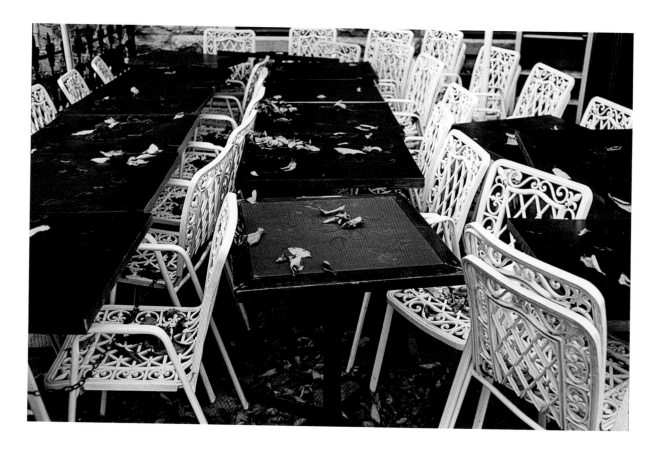

Ever since the invention of the photographic medium, photos have been either color or black-and-white. Color theory does not distinguish between the two and includes black, white, and gray in the spectrum of visible colors, albeit in the special form of monochromatic colors. The word "colorful" is often used by untrained observers to describe pictures in a deprecating fashion. Color theory uses the word "colorful" to distinguish between achromatic black, white, and gray tones and "real" chromatic colors. The correct term

for a collection of colors that don't harmonize is, "non-systematic chromaticity".

A painter chooses the quality and the amount of a color that is used in a painting, whereas the size and arrangement of colors and shapes in a photo can only be influenced by altering its composition. With the exception of deliberate under- or overexposure, the colors in a subject are determined by the structure of the subject itself. Black, white, and chromatic colors can be pure or mixed. Using white to lighten colors or black to darken them is a

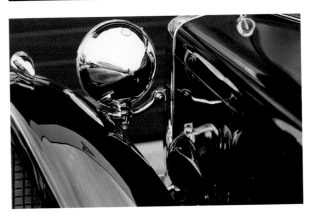

	2	
1	3	5
	4	6

well-known technique, while black and white themselves represent the extreme ends of the dark-to-light scale and can only be modified in a single direction.

White is often described as the "perfect color" and is very rarely associated with negative events or feelings. Physically speaking, white represents the sum of all the colors present in the visible spectrum. White light can be separated into its component colors using a prism. A lack of light produces darkness—in other words, black.

Red is the strongest and warmest chromatic color, and almost always conveys closeness. Blood and fire are the most fundamental human associations with the color red. The combination of black, white, and red has a strong visual effect, which is why this color combination is often found in warning signs.

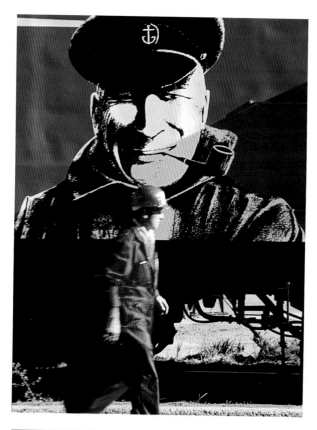

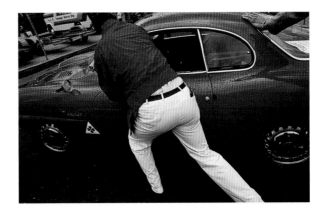

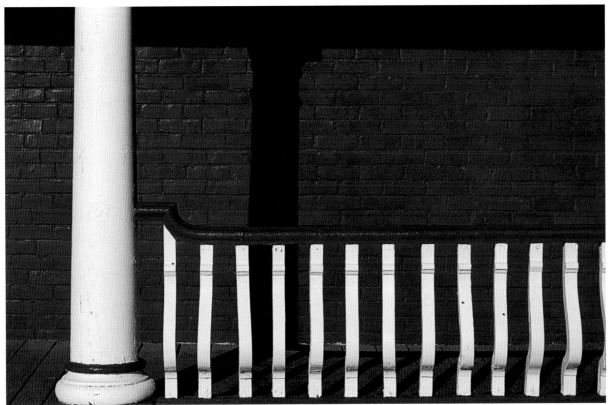

About the Photos

The strict use of a single color alongside black and white ensures that the photos are seen as belonging to a series. The compositions differ only in the amounts of each of the three colors they contain. Red is the dominant factor in photos #2, 4, 11, and 12, while black has the upper hand in #1, #5, and #6. Comparatively small amounts of red jostle for attention in photos #1, 3, and 8, just like the black line in #9. There are no formal limits to composition for a color-based theme like this one.

Broad shapes are the dominant feature in photos #1, 2, 4, 11, and 12, whereas points and lines are more significant in #3, 5, 8, and 9. Photo #10 is dominated by a texture that is superimposed on the entire subject, while the contrasts between large, small, and different shades of red are what make #7 interesting.

28 Complementary Colors: Red and Green

Simultaneously Harmonious and Expressive

Colors that are located near one another in the color circle have similar effects and belong to specific color groups. An image only becomes interesting when the colors within it contrast with each other. Colors that lie on opposite sides of the color circle are known as complementary colors and have highly differentiated tones. The most well-known and obvious color pairings consist of one primary and one secondary color. These are: red/green, blue/orange, and yellow/violet. Complementary colors mutually boost each other's effects but need to remain in proportion to one another in order to be effective. The emphasis placed on each of the colors is determined by its grayscale value. These values can nowadays be measured using machines, but nevertheless rely on a trained eye and appropriate skill if they are to be judged properly. Goethe's *Theory of Colors*, published in 1810, posited harmonic proportions for complementary colors that are still valid today. Goethe felt that red and green relate to each other in proportions of 1:1, while blue and orange harmonize at 2:1. He valued violet and yellow (with their significant difference in brightness)

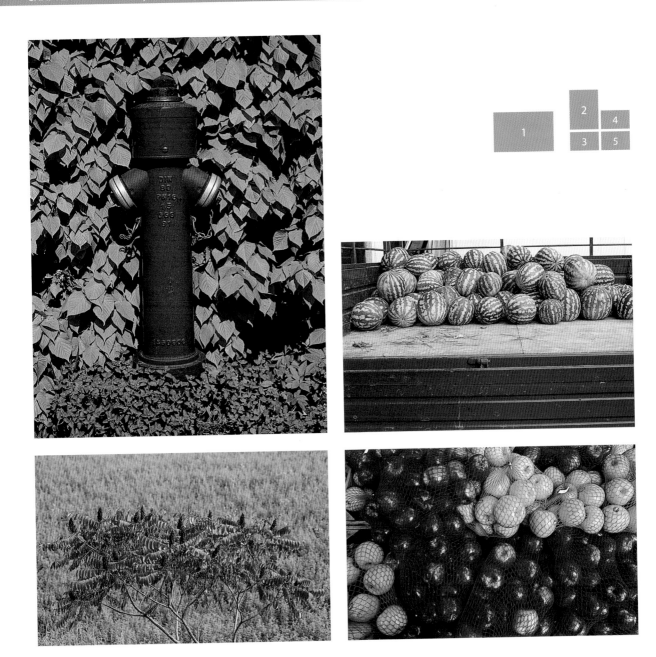

with 3:1. These values allow pairs of colors to enhance each other's effects while retaining balance within an image. Consistent harmony and balance can, however, have a slightly stuffy, uninteresting effect.

Complementary colors can also be used in other, more expressive quantities. The strength of complementary color contrasts depends on the relative sizes of the colored areas within an image, and you can change the sizes of the major shapes by adjusting your framing. Our instincts cause us to perceive harmonious color proportions as balanced.

Whether the effects produced by other, more expressively proportioned colors are pleasing is, of course, a completely subjective matter.

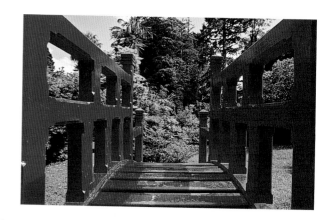

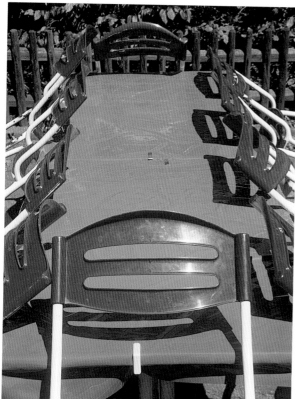

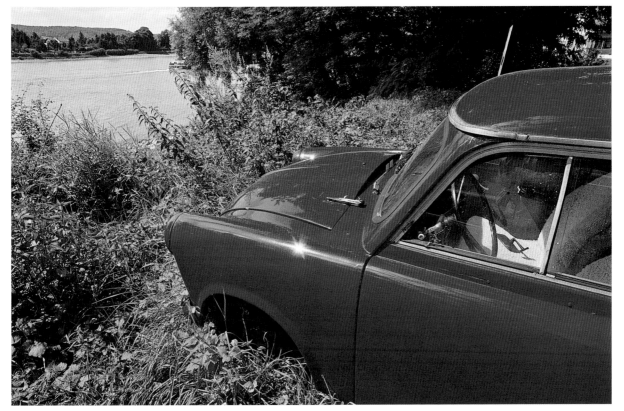

About the Photos

A red/green contrast is most harmonious if an image contains the two colors in equal parts and without too much light/dark contrast. We are capable of perceiving colors as balanced even if they are distributed among multiple surfaces within the frame. While the areas of color in photos #3, 4, 5, 8, 11, and 12 are predominantly contiguous, photos #6, 7, and 9 show more fragmented coverage.

Although red and green have the same grayscale values, small amounts of red harmonize better with large amounts of green than small amounts of green harmonize with red. These differences are, however, subjective, and the opinions of artist and observer are often different in this respect. Not everyone will find the small red areas in photos #1 and #2 interesting or suspenseful. The green of the plant in #10 is unlikely to be perceived as an active color.

29 The Multicolored Spectrum

A Wide Range of Colors Arranged Freely or Systematically

In order to identify objects, the human eye requires contrast, which is particularly strong between contrasting primary colors. With the help of rainbows and prisms, we can visualize the other, secondary colors (green, orange, and violet) that make up white light. Rainbows have a magical effect on people and have, over the centuries, been repeatedly painted and sculpted, both figuratively and abstractly.

Primary colors cannot be created by mixing, but secondary colors can be created by mixing two primary colors. Mixing blue and yellow gives us green, yellow and red make

orange, and red and blue make violet. All six primary and secondary colors are easily identifiable, and distinguishable color contrast still exists in images that contain four, five, or even all six of them. However, the more colors an image contains, the greater its contrast between light and dark. Whether an image contains ordered or randomly arranged colors, yellow is the always most obvious color, and our subconscious instinctively looks for its opposite. If an image contains all the colors of the spectrum in equal amounts, three of the total of seven color contrasts will determine its

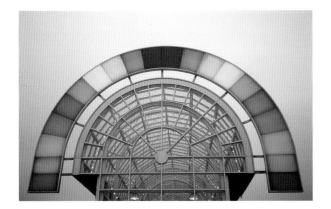

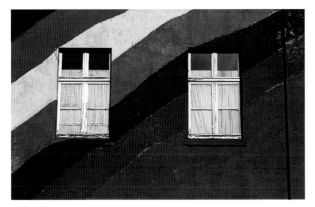

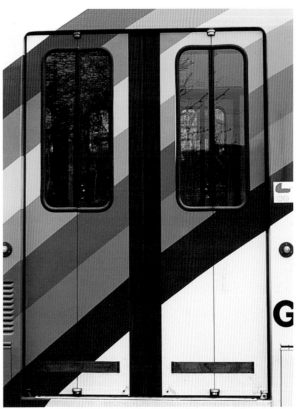

overall look. Overall color contrast is the most obvious characteristic of an image, followed by the light/dark contrast between yellow and violet and the cool/warm contrast between blue and red/orange tones. If they all appear together, these characteristics produce colorful, attention-grabbing images.

About the Photos

Even if the colors are not shown in the correct order, photo #2 illustrates the way people like to copy nature's own semi-circular rainbow shape. It is often difficult to capture entire rainbow pictures without using an ultra-wide-angle lens, but photos #3, 5, 7, 9, 10, and 11 show that a quarter-circle or even just a short arc is sufficient to conjure up the whole rainbow in our mind's eye. Representations of the spectrum are usually painted in two dimensions. Photo #4 shows a three-dimensional spectrum created using projection, and

#6 is a detail from a public sculpture made of large colored rings.

A "colorist" approach to the use of colors produces no clear borders between individual colors, while "linear" use of colors clearly defines each color area. Photos #1, 4, and 11 show a colorist approach, while all the others are based on linear techniques. Spectra are usually (but not always) portrayed using a systematic color order. Here, only #1 and #12 show a truly random color sequence.

30 Monochromatic Pastels

Light Colors and Color Groups

Limiting the range of colors to a single tone or group of tones can give an image a highly individual look. Viewed singly, monochromatic images are often quite dull. However, including them in a series can inject life into otherwise muted photos. Compositions that include only one color or just a few closely related tones can often only be achieved using very tight framing. The range of monochromatic images is not determined by the grayscale value of the colors they contain, and so it includes all similar colors regardless of the brightness (or darkness) of their base tones.

A lightened color often crosses an undefined semantic border at which, for example, "light red" suddenly becomes "pink". The practice of lightening colors is known as "fading to white" and implies that the resulting color is no longer pure. The opposite effect, known as "fading to black", produces different reactions depending on the color that is being altered. Blue simply tends toward darker blue, while red is transformed into brown.

Painters can change the colors they use at will, whereas photographers (apart from slight changes to color intensity

caused by deliberate under- or overexposure) can only change the colors in an image by adjusting the composition or waiting for the light to change. Overexposed photos are also known as "high key" photos and are often seen as a separate art form. Apart from deserts or fields, monochromatic scenes occur most often in architectural or other urban contexts. Lateral light emphasizes uneven surfaces and architectural features to produce shadows that create darker variants of the subject's own base color.

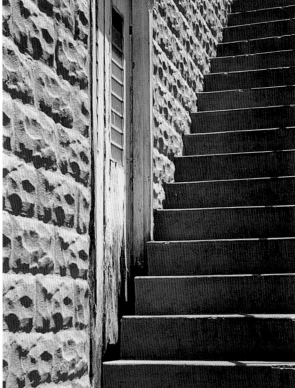

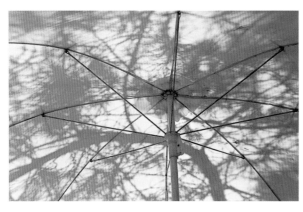

About the Photos

Single-colored objects without texture or detail are generally uninteresting, unless you use them as a meditative aid to getting "lost in color." Details such as the fine tonal differences between the building and the sky in #6 or the precise textures and patterns in #10 immediately attract our attention. Distinct objects such as the window or the plants in photos #3, 5, and 9 directly define the image. Shadows produced by direct sunlight can be seen in #7, 8, and 11, while in #12, the architecture itself produces darker surfaces that contrast with the building's basic color. Photos #1 and #2 are composed using an explicit but limited range of colors. Contrasting points or lines can also make single-colored images more interesting. The folded curtain in #2, the potted plant in #3, the triangular "hat" in #4, and the contrasting green stripes in #13 are all examples of this kind of invigorating detail.

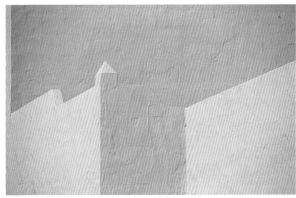

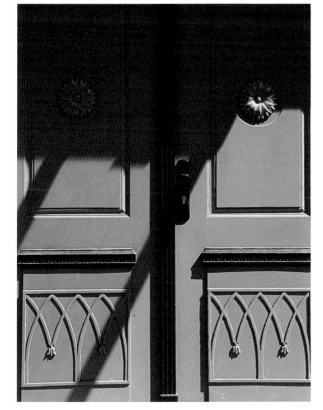

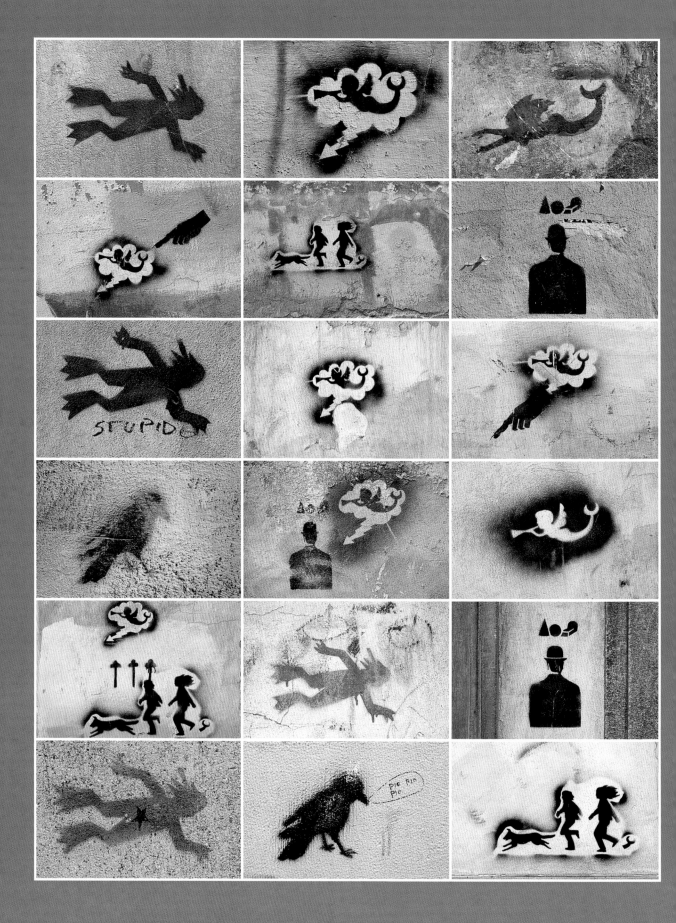

Part 4

Serial Photography Special Themes

The composition of serial images based on rare, odd, or purely artistic themes still depends on the use of points, lines, shapes, and color contrast. Opinion is sure to be divided on which subjects are interesting enough to be classed as an independent theme. The quality and overall look of a series also depends on the quantity of pictures it contains. In order to be classed as a series, a work should comprise at least five or six separate images. There is, of course, no upper limit to the number of images a theme can encompass.

It is difficult to avoid making repeat observations when analyzing large numbers of photos, such as the 44 series included in this book. Certain common elements are noticeable in many of the themes. For example, points are a major element in the *Doubling Up*, *Triples*, *Street Lamps*, and *Shoes and Gloves* sections, whereas lines are the predominant design element in *Brushes*, *Stairs*, *Tables and Chairs*, *Palm Trees*, and *Lines and Stripes*. Circles, rectangles, and squares are the major shapes in the *Street Signs*, *Traffic Mirrors*, *Manhole Covers*, and *Balloons* sections.

Different art forms use different approaches to producing images, but the term "picture" nearly always refers to a two-dimensional work. The 2:3 rectangle is the most common image format, but squares and elongated rectangles are also popular. Other basic shapes, such as circles or triangles, are rarely the basis for two-dimensional images.

Painters and illustrators start with an empty background and create their images gradually. They are able to change fundamental forms and colors at most stages during the creative process. Traditional photography involves making decisions regarding film, framing, and focal length in advance and then exposing the entire image in a split second. It has always been possible to alter certain aspects of a finished photo in the darkroom, and nowadays, digital image processing techniques make adjusting photographic images easier than ever before. Changes to image content can have deceptive, or even criminal effects, especially if the images involved are of a political or commercial nature, but there are no limits to the changes you can and should make for purely artistic purposes.

31 Mirror Images

Doubling Up Vertically and Horizontally

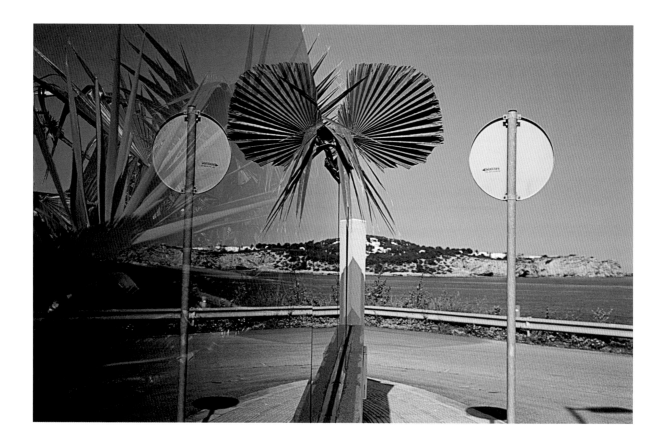

Painters used mirrors to create visual effects long before photography was invented. Mirrors can be used to include objects in an image that are located outside the frame, or to duplicate a subject.

The theme of the images printed here is the duplication of a major image detail. Symmetry is a major element in this type of image, and it can be conjured by a conventional mirror, water, glass, or any polished surface. This type of symmetry usually has a harmonious effect, and the image is generally arranged around a vertical or horizontal central axis. It is up to the photographer to decide where this axis divides the frame.

A traditional landscape format is better for photographing horizontally mirrored subjects than a portrait format, as this emphasizes the subject itself rather than the proportions of the division within the frame. The division of the frame into right-hand and left-hand sides is especially obvious if you shoot a vertically mirrored object in landscape format. In order to preserve symmetry in such photos, it is

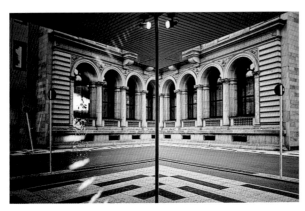

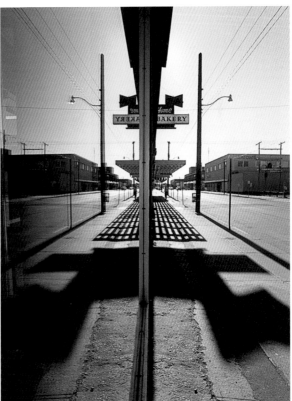

usually best to place the vertical axis in the center of the frame.

A subject's mirror image usually appears darker than the subject itself, unless it is reflected in a traditional mirror or silvered glass. In this case, the mirrored brightness and color values will be very similar to those in the original subject. An observer will always attempt to recognize the content of an image before reacting to it emotionally. It is only once this reaction has taken place that the composition and color structure of an image can be analyzed. The spe-

cial characteristic of mirror images is that they produce new shapes—in landscapes, in the form of stretched oval shapes, and in an architectural context, the form of new, expanded versions of existing detail.

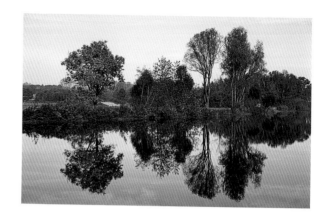

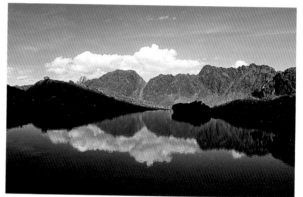

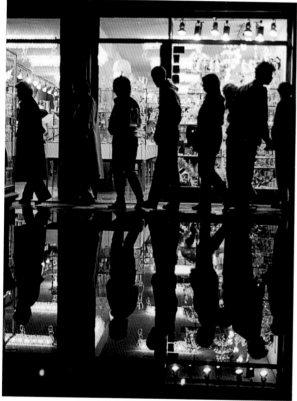

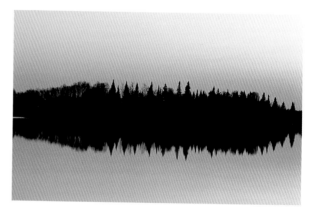

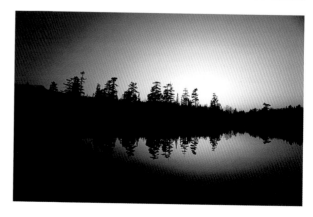

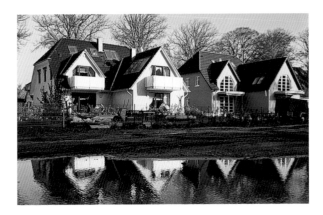

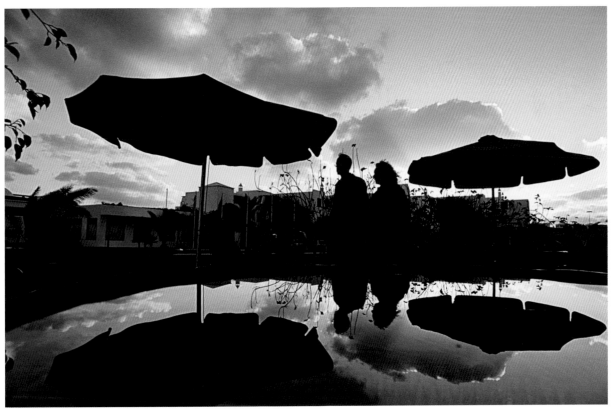

About the Photos

The most interesting mirror images can be captured using wide-angle lenses. Vertical lines divide both portrait and landscape format images into left and right sides, illustrated clearly by photos #1, 2, 3, 4, and 5.

Mirrored subjects can also cause optical tension between shapes and colors, also shown by #1, 2, and 3. Photos #2 and #5 illustrate how mirroring can lead to the apparent creation of new forms and shapes. Horizontal lines divide an image into upper and lower halves, and invert the reflected subject in the lower half. There are obvious differences between the details in the upper and lower portions of #6, 7, 8, 11, and 12, whereas the two halves of the image in #9 and #10 simply melt into each other.

32 Automotive Reflections

Inverted and Abstract Images

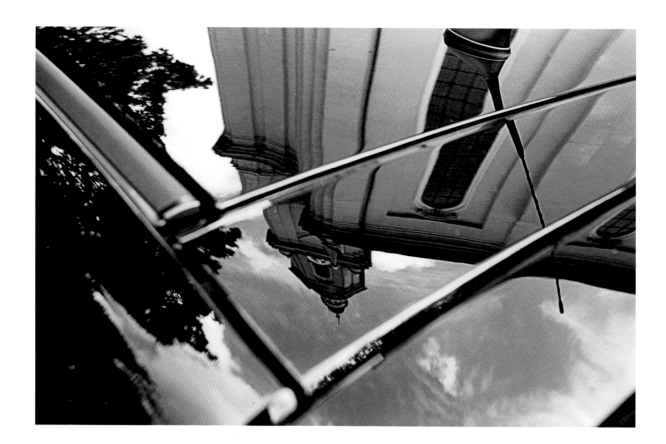

This special theme is tricky in its own special way. The prestige value of cars varies from country to country, and with it the degree to which paintwork and windows are kept clean and shiny. Cars that are used as utility vehicles tend to be less well cared for and can be quite dirty. If necessary, it is possible to remove some dirt from a stranger's car without attracting too much attention!

It can be difficult to compose frame-filling images of reflections in cars due to the rounded nature of automotive bodywork. Curved surfaces produce dynamic-looking reflec-

tions but make it hard to preserve compositional balance. Close crops and portrait format images especially tend to produce a high degree of abstraction. The more you include the car itself as the subject and the smaller the role played by the reflections, the easier it will be to compose your image. Wide-angle lenses are the best choice for shooting this type of theme. You can influence the effect of reflections by changing your standpoint, and frontal shots produce calmer, more static images than lateral shots.

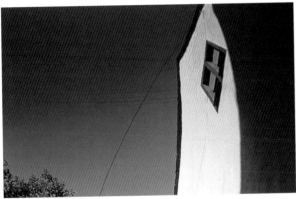

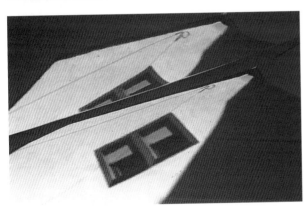

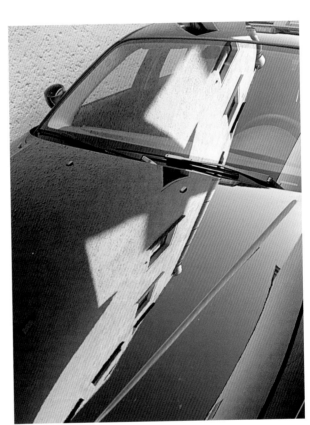

The basic color of an image is determined by the color of the car. Polished, black cars provide the clearest reflections and don't require you to adjust your exposure. If you find an interesting reflection near a parking lot, you can take multiple shots of the same reflection using different colored cars as a basis. Reflections in the body of a car are usually complete, whereas photos of reflections in car windows often include parts of the vehicle's interior. Photos of full-frame reflections in car roofs can later be inverted to switch the orientation of reflected objects such as houses, trees, and street lamps back to normal.

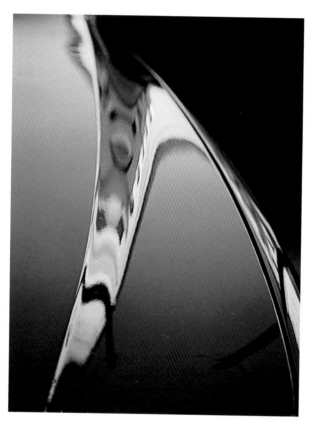

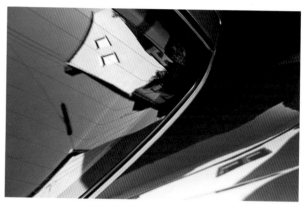

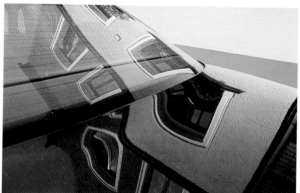

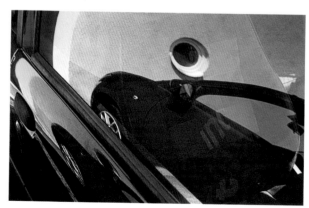

About the Photos

The blue, yellow, and red photos (#1, 2, 3, 4, and 5) make an interesting primary-colored monochrome series. The complementary contrast between blue and yellow/orange in photos #1, 5, 6, and 11 is the result of taking pictures of black cars. You can, of course, look not only for monochromatic images like #7 and #10, but also for multicolored subjects like the ones in photos #6, 8, and 9. The perspective in the reflections of houses and other objects is often interesting but sometimes quite severely buckled due to unevenness in hoods, trunks, or windshields. Photo #9 was taken between two parked cars and includes the reflection of a reflection.

33 Still Lifes

Public and Private Surprises

European culture has a long tradition of still life imagery that has produced many skillfully painted, almost photographically precise renditions of plants, fruit, kitchen scenes, and museum rarities. Many details in older still life paintings are intended to remind the viewer of the transience of life on Earth.

In the early days, most photographers concentrated on portraying people, but a few also followed the still life tradition in their work. Today, still life photography is generally part of the product and advertising photography ouevre.

Advertising photographers often photograph plants and flowers for practice. Karl Blossfeldt, Reinhart Wolf, Irving Penn, and Robert Mapplethorpe are just some of the 20th century's more notable still life photographers. In spite of their apparent naturalness, still lifes are often strictly staged. Photos of pumpkin fields, apple trees, or seed pods on a branch are generally considered to be nature photos, not still lifes.

The individual objects that make up a still life are usually quite small and quickly form additional textures if they are

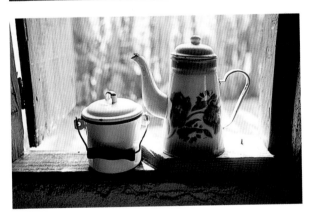

arranged in large numbers. You can, of course, construct still lifes from larger objects, too. It is more difficult to arrange a pleasing still life from scratch than it is to simply keep your eyes open for accidental still life opportunities at vegetable markets, garage sales, or at home in your kitchen or garage.

It is important to clearly separate the subject of a still life from its background, and shooting to deliberately defocus the background is the simplest way to achieve this. All of the still lifes printed here are found scenes in which the main subject is not always immediately recognizable. The composition of the individual images relies entirely on framing and the found arrangements of the subjects they portray.

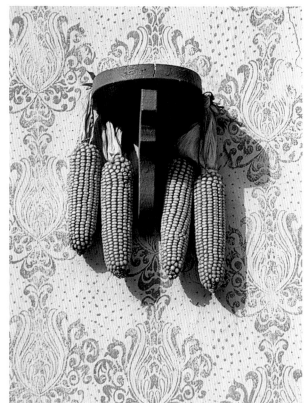

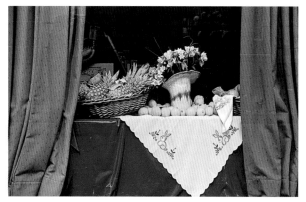

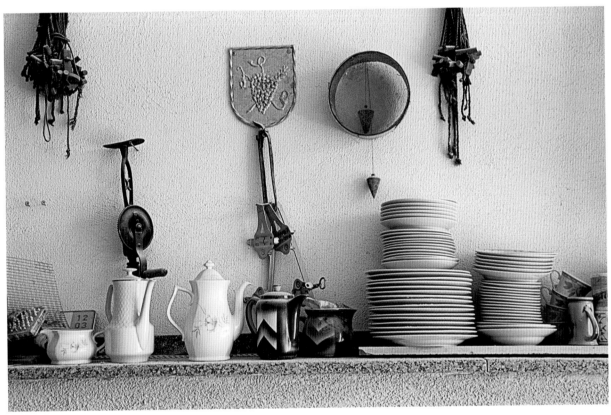

About the Photos

Detailed backgrounds, as in photos #1, 5, 10, 11, and 12, emphasize the subject without distracting the viewer. Photos #2, 6, and 8 are images that use selective focus on the subject with out-of-focus backgrounds to achieve their effects. The owner of the fruit store in #7 used an arrangement reminiscent of a stage curtain to present her wares. The maize cobs in #9 harmonize beautifully with the wallpaper in the background. Patterned glass provides added texture in #3 and #4, and a degree of genuine chaos adds character to #10. The random collected objects on a garage shelf in #12 have a special charm of their own.

34 Glass Façades

Realistic and Abstract Reflections

We are faced with the phenomenon of mirror images every day of our lives. Every morning, we see ourselves and parts of our familiar surroundings in precise detail, albeit flipped 180 degrees. Photographers often use mirrors to take self-portraits and also to indirectly observe and photograph others. The resulting images are generally "straight" and realistic-looking, whether they represent objective views or subjective interpretations of their subjects.

There are two major types of public reflections that compete for our attention; store windows and glass façades.

Reflections in store windows combine interior and exterior elements in a single, often surreal photo, but the best reflections occur when the windows themselves are in shadow and the reflected objects are brightly lit. It is nevertheless important that the spaces behind the windows remain lit so that they too can become part of the finished image.

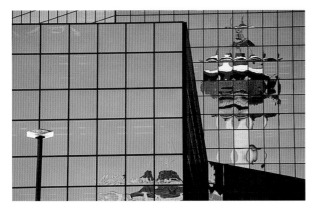

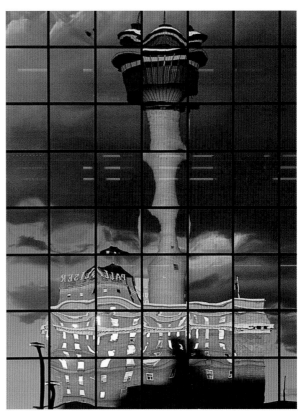

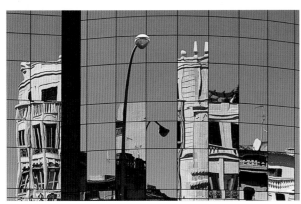

Large-scale glass façades have, in recent years, radically changed the views in cities around the world, and represent a wide-ranging photographic theme of their own. In spite of the considerable size of the individual sheets of glass, the surfaces they cover are nevertheless divided into regular patterns of squares or rectangles by the steel girders supporting them. It is only possible to keep these lines parallel to the edges of the frame by using long lenses or shooting from a raised viewpoint, although nowadays it is relatively simple to correct converging lines digitally. Sheets of glass can never be mounted 100 percent evenly and are, in themselves, not completely flat. They thus produce distortion and unexpected shifts within reflected subjects. Parts of the subject are often duplicated or disappear completely in the gaps between the individual panes.

Arrangements of small mirrors produce interesting, broken-down views of otherwise familiar objects. Close crops often require the viewer to take a second, closer look before a reflected object can be recognized for what it is.

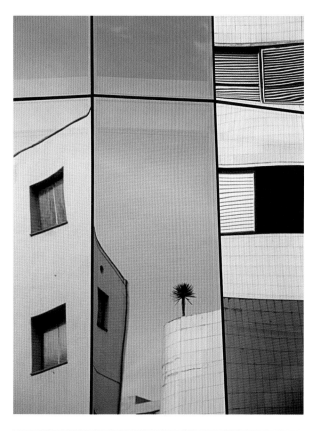

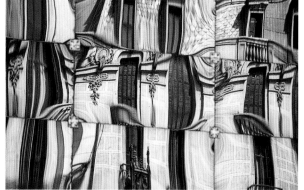

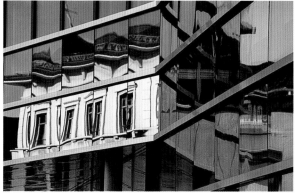

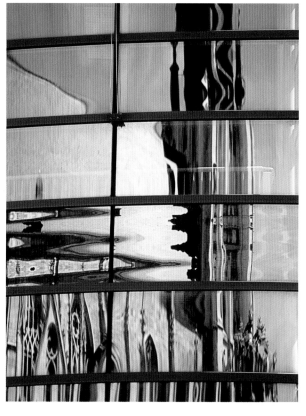

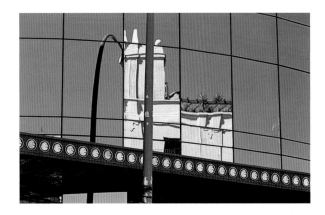

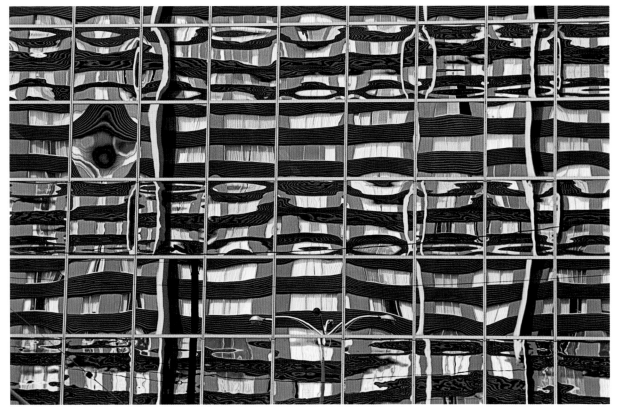

About the Photos

It is usually necessary to use focal lengths of 135 mm and above and to mount your camera on a tripod if you want to photograph glass façades in cities. The physical limits to the size of glass elements often result in buildings with enormous checkerboard patterns, illustrated by photos #2, 3, 4, 5, and 7. Here, the reflections are partially distorted but still recognizable. The tighter crops in #6 and #10 give us a more detailed view of the reflected architectural details. Some buildings are clad in reflective metal. Metal cannot be as precisely tooled as glass, resulting in the heavy distortion visible in #1, 8, and 11. The partially distorted reflections in #9 vie for our attention with the red lines in the building's façade.

35 Packaged Objects

From Casually Covered to Beautifully Bound

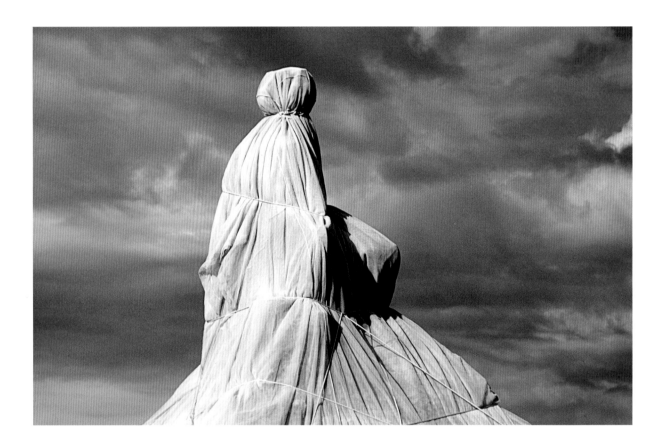

Normally, a quick glance is enough to check our surroundings for potential danger or interesting input. As soon as our view is blocked, our deep-seated instinct for survival makes us take a closer look at what is going on. In everyday situations such as riding a bicycle, driving a car, or walking along a street, we constantly survey our surroundings for changes in detail.

When we view pictures, we can give them our undivided attention. The first step involved in viewing a well-composed image is recognizing the main subject, which

usually occurs within a split second. The recognition process takes longer if an image portrays an unfamiliar object or a familiar object presented in an unfamiliar way.

When we view packaged objects, it takes a while to comprehend the nature of the material that is blocking our view. The transparency of packaging materials can vary enormously. The best-known objects that hinder our view are fences, gratings, and textured glass. We are used to the limits imposed on private property or the safety provided by fences that separate people from animals. A cage that

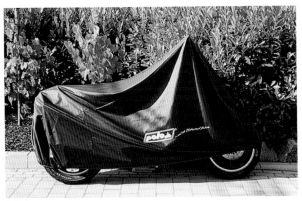

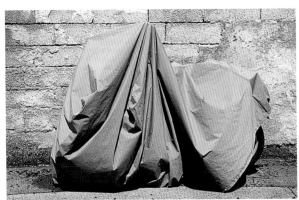

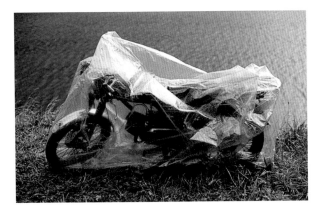

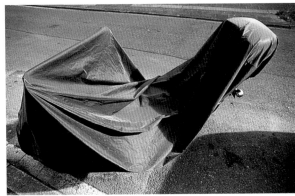

covers the entire frame is impossible to overlook but doesn't prevent us from recognizing the animals inside it.

Public ornaments in cities are often packed for cleaning or protection using a variety of materials that include straw mats, sackcloth, plastic tarpaulins, and nets. Sometimes entire buildings are covered, while at other times smaller objects, such as a single bus shelter or a sculpture, are temporarily relieved of their normal appearance. As with other themes, the variety of potential subjects is what makes this theme so fascinating. Suitable images can be found in pub-

lic or in private and often turn into subthemes of their own, like the covered motorcycles shown here or the covered cars in the frontispiece. You can also approach this theme by packing things yourself instead of a looking for found objects.

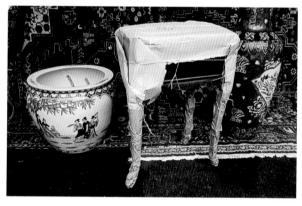

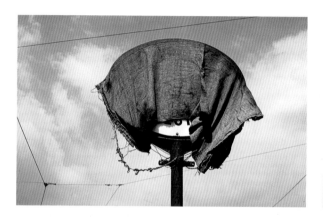
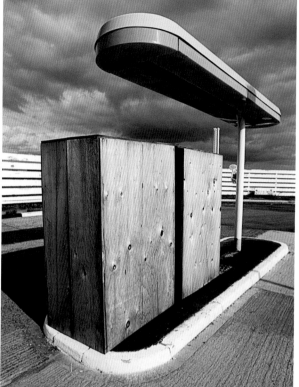

About the Photos

Photos #2, 3, 5, and 6 give away very little about the covered object, while the semitransparent cover in #4 is much more generous with the secrets it is keeping. The bus stop sign and the handcart in #7 and #9 have both been covered quite carelessly, whereas the saucepans in #11 are individually and very precisely wrapped. The carefully packed table in #8 is instantly recognizable, but the object in #12 remains a secret. Photo #1 suggests a packed sculpture, and the covered gas station in #10 is unmistakable. Photo #13 is at first glance a puzzle. The photo is actually of yachts in dry dock on the island of Ibiza.

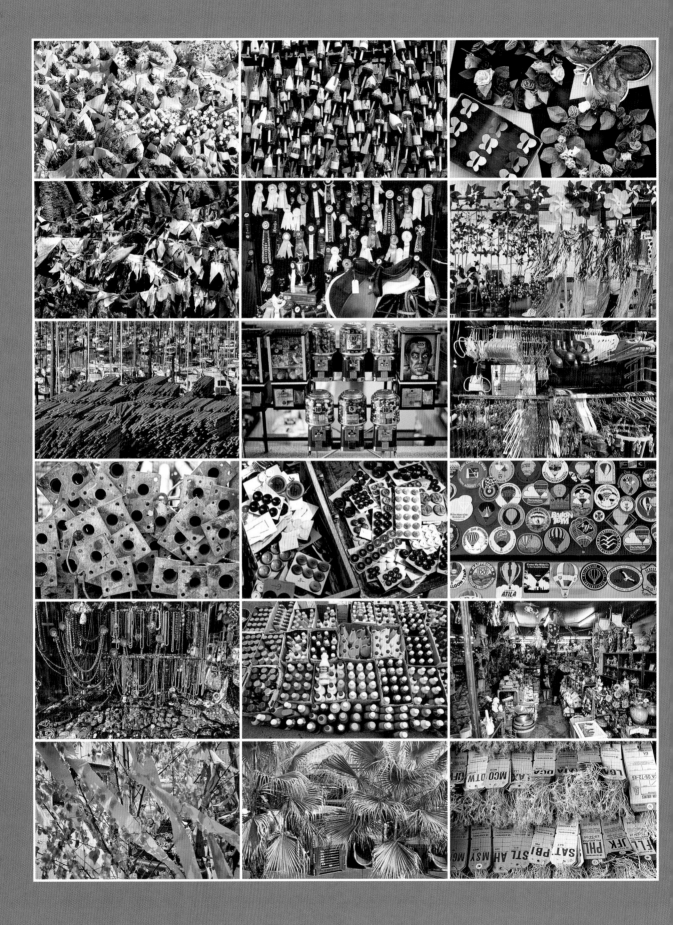

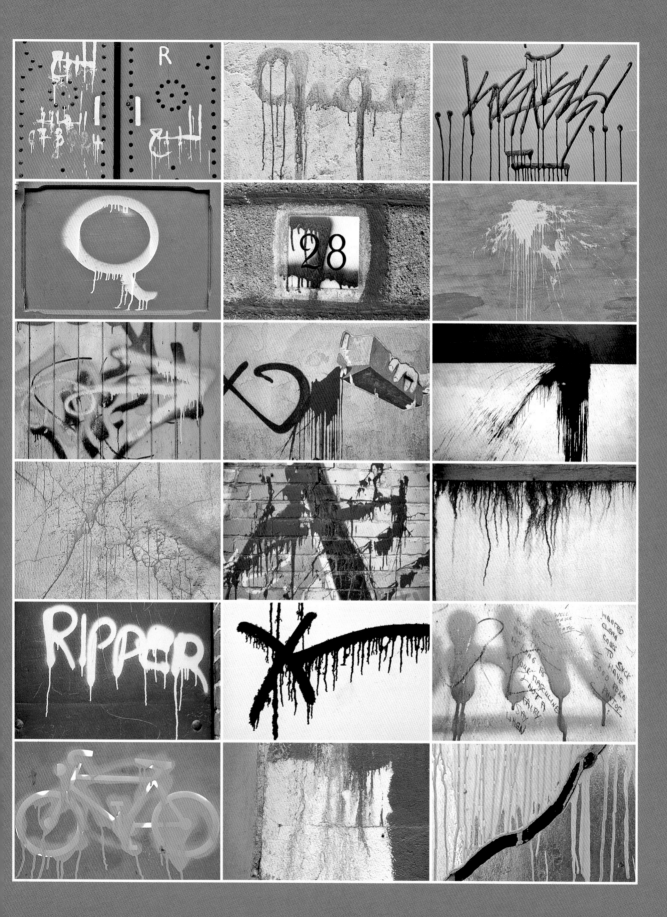

36 About the Tableaus

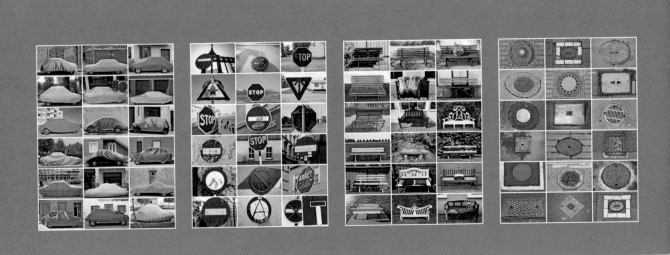

A tableau is the most effective way to present a photo series. The identical size of the individual images compels the viewer to compare them to each other. In order to fit the page format, the tableaus printed in this book have been laid out in portrait format. In addition to the theme itself, the number of photos in a series plays a role in the effectiveness of the finished work. If you print individual images at about 4 × 6 inches, you will end up with a tableau that measures at least 20 × 30 inches. Most private apartments are too small for this scale of presentation, but the 10 × 30 inch frames that have recently become popular are also suitable for displaying five or six 4 × 6 inch photos in a vertical row. This a relatively small number of images, but it will usually suffice to make a theme recognizable.

1 Covered Cars (Page v)

Observant viewers are immediately attracted by the differences between images in which the basic subject is easy to identify. Here, the cars face both ways. Some are covered with covers and are completely protected, while others are partially uncovered. The range of colors and patterns is almost endless.

2 Street Signs (Page vi)

Most signs forbid us to do something, and you have to look hard to find one that actually invites us to proceed. The tableau reveals a wide variety of shapes and meanings which could be reshuffled to only include stop signs.

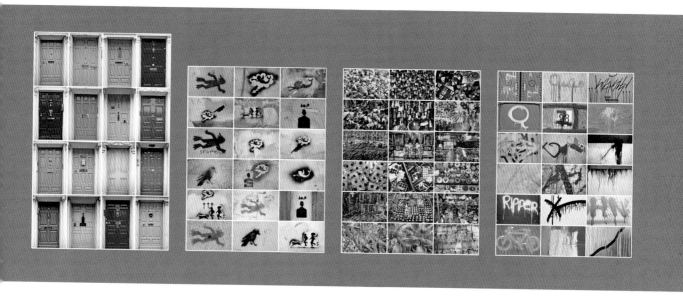

3 Benches (Page viii)

Single chairs often appear somewhat lost. However, the same is not true of a lone bench. The differences between photos in this series are the benches' locations, colors, intended usage, and materials.

4 Manhole Covers (Page 82)

As mentioned in the text, this broad theme can be divided into subthemes that address the different shapes of manhole covers.

5 Colored Doors (Page 104)

The shape of the subject is perfect for display in a portrait format tableau. Positioning different colored doors in different places can alter their effects. In this case, the triangle inferred by the three red doors is the dominant element in the composition.

6 Stencil Graffiti in Florence (Page 126)

"Photographer's luck" can sometimes put you in the right place at the right time, guiding you to a serial subject with an immediate and absolute commonality.

7 Swarms (Page 148)

The over-the-top effect of the individual images is accentuated by the tableau form. It is tempting to cover the surrounding images in order to concentrate on just one.

8 Color Runs (Page 149)

This subtheme exists primarily as a side effect of graffiti. Once you start to look for them, you will discover color runs that are part of many other themes, too.

37 Displaying Serial Images

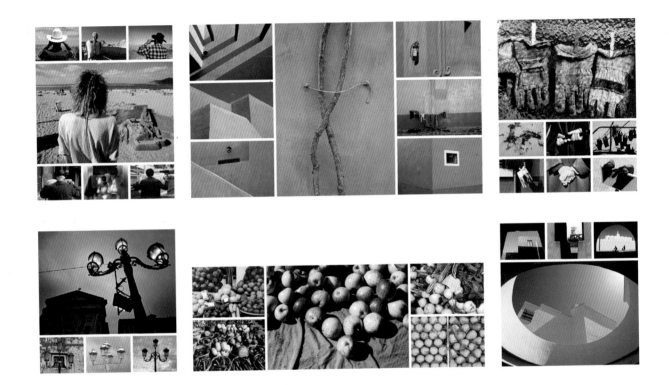

As already mentioned, the tableau form is an effective way to present series of photos, but it involves the risk of the viewer mistaking your series for a sequence. A series can also be presented using different sized images and mixed portrait and landscape formats. A larger image format will, of course, give an image more emphasis within a layout. For the illustrations in this book, we used the height of the larger landscape format images to preserve the overall balance of the individual pages.

The examples on this page show various ways to use square and rectangular backgrounds to present serial images. It is especially important to keep an eye on the distances between the individual images and the distance between the tableau and its frame. If the divisions between individual images are too broad, they can overshadow the compositional lines within the images themselves. The width of your mat should be the same above and to the sides of your tableau, while the lower border needs to be slightly wider in order to produce a pleasing overall effect.